FROM THE MUSEUM OF THE CITY OF NEW YORK

CURRIER & IVES FAVORITES

INTRODUCTION AND COMMENTARIES BY

A. K. BARAGWANATH

Senior Curator of the Museum of the City of New York

AN Artabras BOOK

CROWN PUBLISHERS, INC. NEW YORK, N.Y.

-4

FRONT COVER The Road — Winter Commentary on page 104

Library of Congress Cataloging in Publication Data

Currier and Ives. 50 Currier & Ives favorites, from the Museum of the City of New York.

"An Artabras book."

1. Currier and Ives—Catalogs. 2. United States in art—Catalogs. 3. Lithography—19th century— United States—Catalogs. 4. New York (City). Museum of the City of New York. I. Baragwanath, A. K. II. New York (City). Museum of the City of New York. III. Title. NE2312.C8A4 1978 769'.92'4 78-2205 ISBN 0-89660-007-6

All rights reserved. No part of this book may be reproduced or utilized in any form or by any means, electronic or mechanical, including photocopying, recording or by any information storage and retrieval system, without permission in writing from the Publisher. Inquiries should be addressed to Artabras, Inc., 505 Park Avenue, New York N.Y. 10022. Printed and bound in Japan.

CONTENTS

The Road — Winter FRONT Commentary	COVER 104
Autumn in New England	8–9
Preparing for Market	10–11
Life in the Country	12–13
The Mill-Dam at "Sleepy Hollow"	14–15
Home to Thanksgiving	16–17
American Forest Scene	18–19
Winter in the Country	20-21
American Farm Scenes. No. 4	22-23
The High Bridge at Harlem, N.Y.	24–25
The Grand Drive, Central Park, N.Y	26 –27
Central-Park, Winter	28–29
New York Crystal Palace	30-31
The Life of a Fireman	32-33
The Great Fire of Chicago	34-35
The "Lightning Express" Trains	36-37
Across the Continent	38-39
The Rocky Mountains	40-41
Life on the Prairie	42-43
The Snow-Shoe Dance	44-45
Clipper Ship ''Nightingale''	46-47
The Clipper Yacht "America" of New York	48-49
Summer Scenes in New York Harbor	5051
The Whale Fishery	52-53
The Wreck of the Steam Ship "San Francisco"	54–55

Steam-Boat Knickerbocker	56-57
A Midnight Race on the Mississippi	58–59
The Life of a Hunter	60-61
Mink Trapping	62–63
Beach Snipe Shooting	64–65
Trolling for Blue Fish	66–67
American Winter Sports	68–69
Ice-Boat Race on the Hudson	70–71
The Celebrated Horse Lexington	72–73
Peytona and Fashion	74–75
The American National Game of Base Ball	76–77
The Destruction of Tea at Boston Harbor	78–79
Battle at Bunker's Hill	80-81
Washington Taking Leave of the Officers of His Army	82-83
Perry's Victory on Lake Erie	84-85
Hon. Abraham Lincoln	86-87
The Splendid Naval Triumph on the Mississippi	88-89
The Village Blacksmith	90–91
The Cream of Love	92–93
Hug Me Closer George!	94–95
Kiss Me Quick	96–97
The Four Seasons of Life: Middle Age	98–99
The Bloomer Costume 1	00–101
Glengariff Inn Ireland 1	02–103
Noah's Ark BACK Commentary	Cover 104

INTRODUCTION

By Albert K. Baragwanath

 ${
m T}_{
m HE}$ FIRM OF CURRIER & IVES, the most famous lithographers in America, was founded by Nathaniel Currier (1813-1888) at 1 Wall Street in 1834. Currier had begun his apprenticeship in lithography at the age of 15 with William and John Pendleton of Boston, the country's first significant lithographers. Although Currier's first lithograph was probably the "Ruins of the Planter's Hotel, New Orleans, Which Fell at Two o'clock on the Morning of the 15th of May 1835," the print which brought him immediate local attention was the "Ruins of the Merchant's Exchange," issued four days after the great fire in New York of December 16th and 17th, 1835. A new era of pictorial journalism had begun. This was reinforced when Currier's lithograph of the "Awful Conflagration of the Steam Boat 'Lexington' In Long Island Sound on Monday Eveg Jany. 13th 1840, by which melancholy occurrence over 100 persons perished," was published as an extra for the New York Sun. This was probably one of the first illustrated extras. The presses ran night and day to supply the demand and overnight N. Currier had become a national institution.

Important events of the day continued to be published as well as many prints depicting historical scenes. However, more and more there was a demand for inexpensive decorative lithographs. Currier was quick to respond with the small folio prints usually selling for about twenty-five cents and the larger ones in full color in the three dollar range.

It is estimated that more than 7,000 different lithographs were produced by the firm in its more than seventy-five years of existence. The range was impressive: hand-colored prints delineated the growth of the cities, the bucolic country side, the romantic appeal of the pioneer and westward expansion, the life of the Indian, the era of the clipper ships, the new age of steam on rail and sea, and the panorama of America's historical past. Hunting, fishing, horse-racing, boxing, and other sports of the day were documented. Religious themes and portrayals of the rightness of temperance flourished. Hundreds of prints of pretty girls, children, fruits and flowers were published to decorate Victorian living rooms. Even nostalgic views of Scotland, Ireland, and Europe were available for the homesick immigrants. The life of the fireman, the chores of the farmer, and even the woes of the bachelor were popular subjects. In 1852 Currier engaged as a bookkeeper James Merritt Ives (1824-1895), who had recently married into the family. An artist in his own right, Ives evinced a shrewd insight as to changing public tastes. With business acumen and a critical eye for technical perfection, it was not surprising he was made a partner in 1857. It was at this time that the now familiar term "Currier & Ives" came into being.

Many of the firm's lithographs were reproduced on stone from original paintings by leading artists of the period such as Arthur Fitzwilliam Tait who did so many fine hunting scenes; the New Englander George Henry Durrie; the marine artist James E. Butterworth; Eastman Johnson, and quite a few others. Working more directly for the firm were Mrs. Frances Bond Palmer, generally called Fanny, who was the mainstay of the organization with a record number of prints to her credit; Louis Maurer who did a large number of the Western and country scenes; Charles Parsons, responsible for many fine marine scenes, and Thomas Worth, the great comic artist of the group.

The firm prospered at various New York City addresses until the deaths of Nathaniel Currier in 1888 and of James Ives seven years later. Their sons headed the firm until 1907 when the advances in photography, newer lithographic techniques, and uninspired management forced them to close.

With the passing of the firm and changing tastes in home decor, the popularity of Currier & Ives prints dropped off markedly. Apparently they had suddenly become passé. However, a few years later a young businessman named Harry T. Peters, who also happened to be an ardent horse-lover, came upon a Currier & Ives lithograph of the mare Lady Suffolk tacked to an old barn. He purchased this print, originally issued in 1852, and his collection of Currier & Ives lithographs began. By the time of his death in 1948 he had amassed over 3,000 of the best prints the firm ever published. He also wrote the definitive two-volume work on the firm, entitled *Currier & Ives, Printmakers to the American People,* which included a check list of all the prints he could discover. His family gave his great collection to the Museum of the City of New York, and it is from this collection that these fifty "favorites" have been selected.

Although a general coating of sentimentality glossed almost all the work of Currier & Ives, there still remains a true documentation of the latter half of the nineteenth century—a rich pageant interpreted with the morality and prejudice of the day.

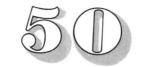

CURRIER & IVES

FAVORITES

AUTUMN IN NEW ENGLAND Cider Making

CIDER WAS NEW ENGLAND'S most important and ubiquitous beverage. Infants drank mulled cider before bedtime; adults drank it with meals and between meals. John Adams, it is reported, regularly drank a tankard of hard cider before breakfast until his death at the age of eighty-nine.

It is not surprising that George H. Durrie, who painted the New England scene so faithfully, would select this theme for one of his works to be put on stone by Currier & Ives in 1866. Harry T. Peters said of Durrie: "His paintings as a group form one of our best records of the old days on the New England farm, a record of a way of life that is fast vanishing."

Durrie did not attempt to depict much of the actual process of making the cider—probably because the technique was so widely known that it was unnecessary to belabor it. Rather, he used the topic as a focal point in creating a typical farm scene with its farmhouse, barn, shed, livestock, and even the local church shining brightly in the distant hills.

At an auction in 1930 it was considered surprising that this print went for as high a figure as \$175. In today's art market it would probably bring over \$3,000.

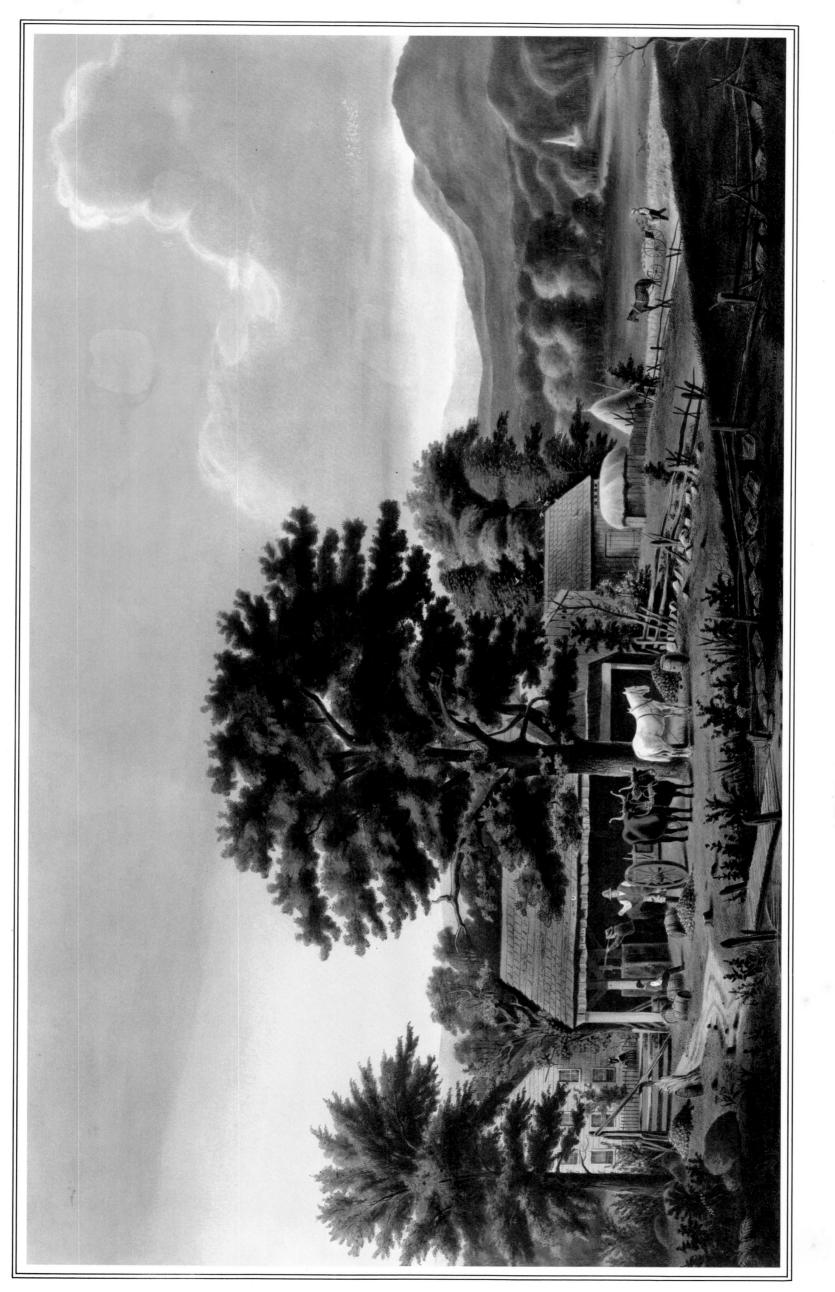

AUTUMN IN NEW ENGLAND

PREPARING FOR MARKET

NO GROUP OF PRINTS is more closely associated with Currier & Ives than that classified as "rural," and this scene is perhaps the finest of those devoted to the life of the farmer. Louis Maurer was the artist for this print, which was executed in 1856.

One of the best descriptions of the print is found in the 1860 catalogue published by the firm: "This is one of those agreeable domestic scenes which are sure to please everybody who loves, (and who does not?) the attractive features of an American Farmhouse. The time is early morning, in summer. A white horse stands facing the observer, in front of a country wagon, to the pole of which he is harnessed. On the right, a boy is holding the nigh horse, a bright bay, whose appearance and condition are creditable to his owner. The farmer stands in the wagon, taking from his buxom dame a basket of eggs, which she is handing up to him. On the stoop of the farm-house stands a two-year old specimen of Young America, who has evidently come out on his own responsibility, with nothing but his nightgown on, endeavoring to attract the notice of a noble Newfoundland dog, standing by his mother. Near by are baskets of vegetables, and bunches of carrots, beets, and garden stuff, ready for market, and a goodly number of fowls, turkeys, ducks and chickens, promenade the door-yard."

In this particular print the coloring could not have been closely supervised for the eggs are the same color as the fruit in the baskets on the ground.

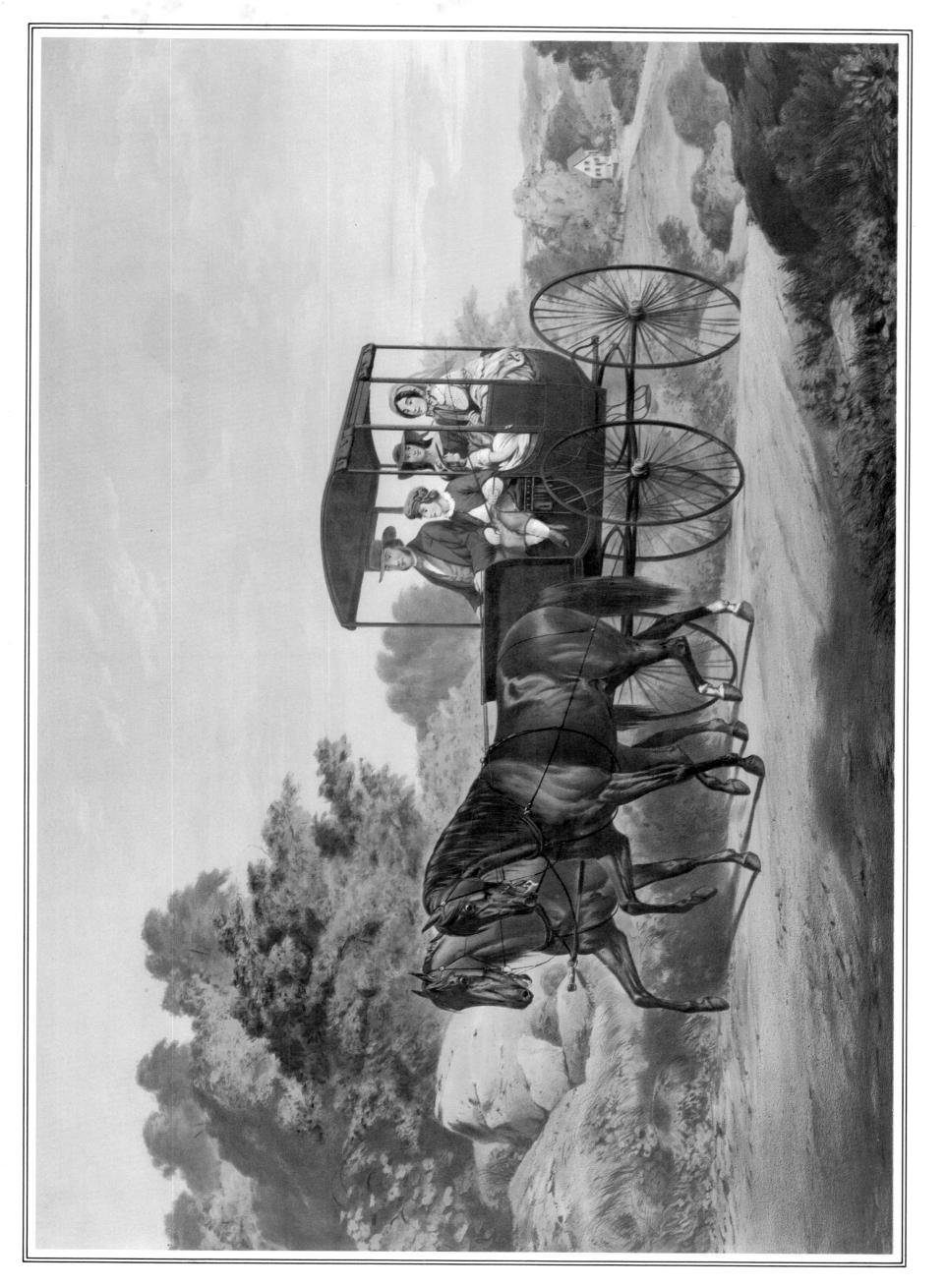

LIFE IN THE COUNTRY

THE MILL-DAM AT ''SLEEPY HOLLOW''

IT IS RARE that a Currier & Ives print is used as the basis for a modern restoration. However, in 1946, through the generosity of John D. Rockefeller, Jr., Sleepy Hollow Restoration purchased this North Tarrytown, New York, property and restored it to the mid-nineteenth-century condition indicated by this print.

Frederick Philipse came from Holland in the 1650s and built a stone house and gristmill about 1683. By the time of his death in 1702 he had amassed an estate of ninety thousand acres known as Philipsburg Manor. Subsequent owners added to the house and made other normal "improvements." In 1969, Sleepy Hollow Restoration completed another major renovation backed by meticulous historical research. This time the manor was restored to the period of Philipse's ownership. The later changes were rectified and the gristmill was made fully operational, actually grinding out flour as visitors watch. Thus this lithograph not only has a great charm of its own but has also been significant in the development of this site, which is now one of the finest restorations open to the public.

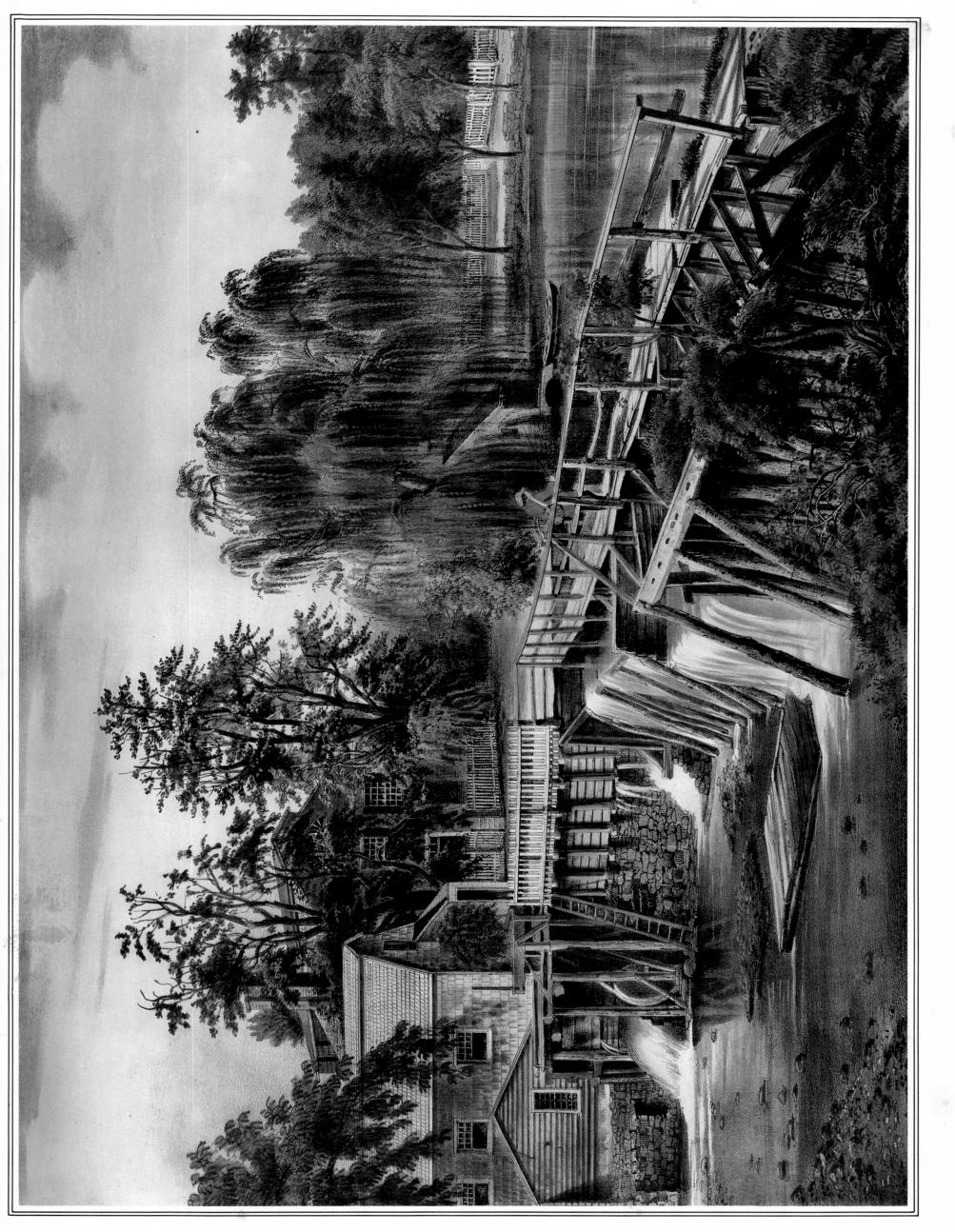

THE MILL-DAM AT "SLEEPY HOLLOW"

HOME TO THANKSGIVING

OF THE MORE THAN seven thousand lithographs published by the firm of Currier & Ives, none has become more popular than this farm scene. Neither the rarest nor the most valuable (that honor belongs to *The Life of a Hunter. "A Tight Fix,*" see page 61), this print is the most famous and best loved. The rather unusual title refers to the fact that the younger generation is returning to the parents' Connecticut farmhouse for America's most cherished New England holiday.

The original painting for this 1867 print was done by George H. Durrie, who spent most of his life near New Haven painting Connecticut scenes. Only two of his works were lithographed by Currier & Ives during his lifetime. This one and five others were done after his death in 1863. The translation of his paintings to the lithographic medium was most felicitous, and the coloring in all cases was particularly faithful to the original.

As one studies the atmosphere created in this scene, it is interesting to learn that Durrie was a meticulous recorder of weather conditions. In one entry of his diary he wrote: "The trees sparkling with icy limbs, made the scene almost enchanting. . . . The weather has been rather cold, especially towards night, when it was quite blustering. The ground, trees, etc. were completely covered with ice, which, glittering in the sun, looked beautiful."

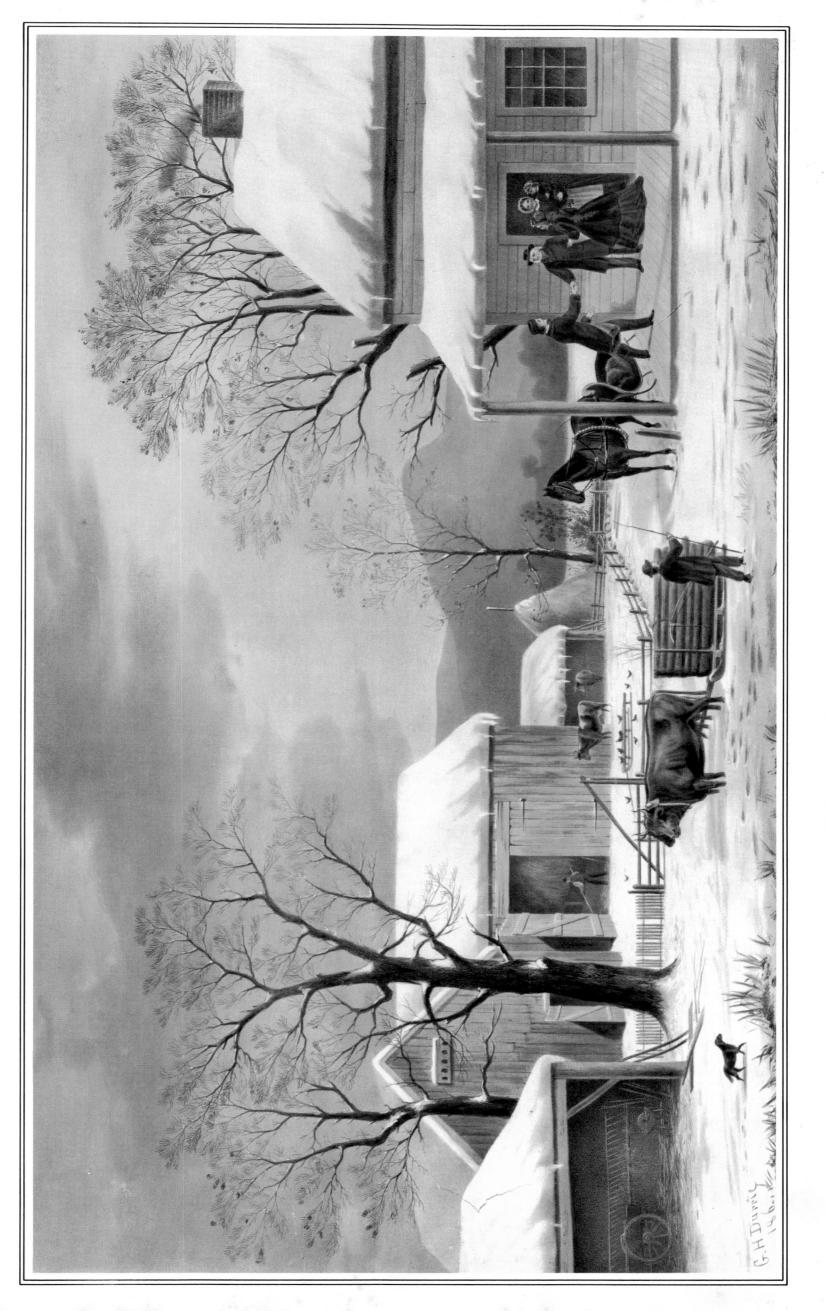

HOME TO THANKSGIVING

AMERICAN FOREST SCENE

Maple Sugaring

MAPLE SUGARING HERALDED THE END OF WINTER and the promise of warmer days with the sap running in the maples. The process of making sugar from this sap took on a holiday atmosphere with the farmers and neighbors joining in the activities, which became also a social event. Even the children helped and were rewarded by being allowed to make sugar cakes in the snow.

In their 1860 catalogue, Currier & Ives aptly described the scene published four years earlier: "From the original Painting by A. F. Tait, lately exhibited at the National Academy of Design, New York. An agreeable picture of a peculiarly American character, showing a maple sugar grove in the early spring time. A light snow has apparently fallen over night, and the ground is thinly covered with a mantle of white. On the logs, near the fire where the sap is boiling, are seated two ladies with a male companion, apparently city folks, come out to taste the sweets of the country. In the distance, an ox-cart is approaching with another party of the same sort. On the left, two 'natives' seem engaged in a discussion, either on the sugar trade or the next election. A number of boys and girls are tending the kettles, bringing up the sap in buckets, or having a good time generally at 'sugaring off.'"

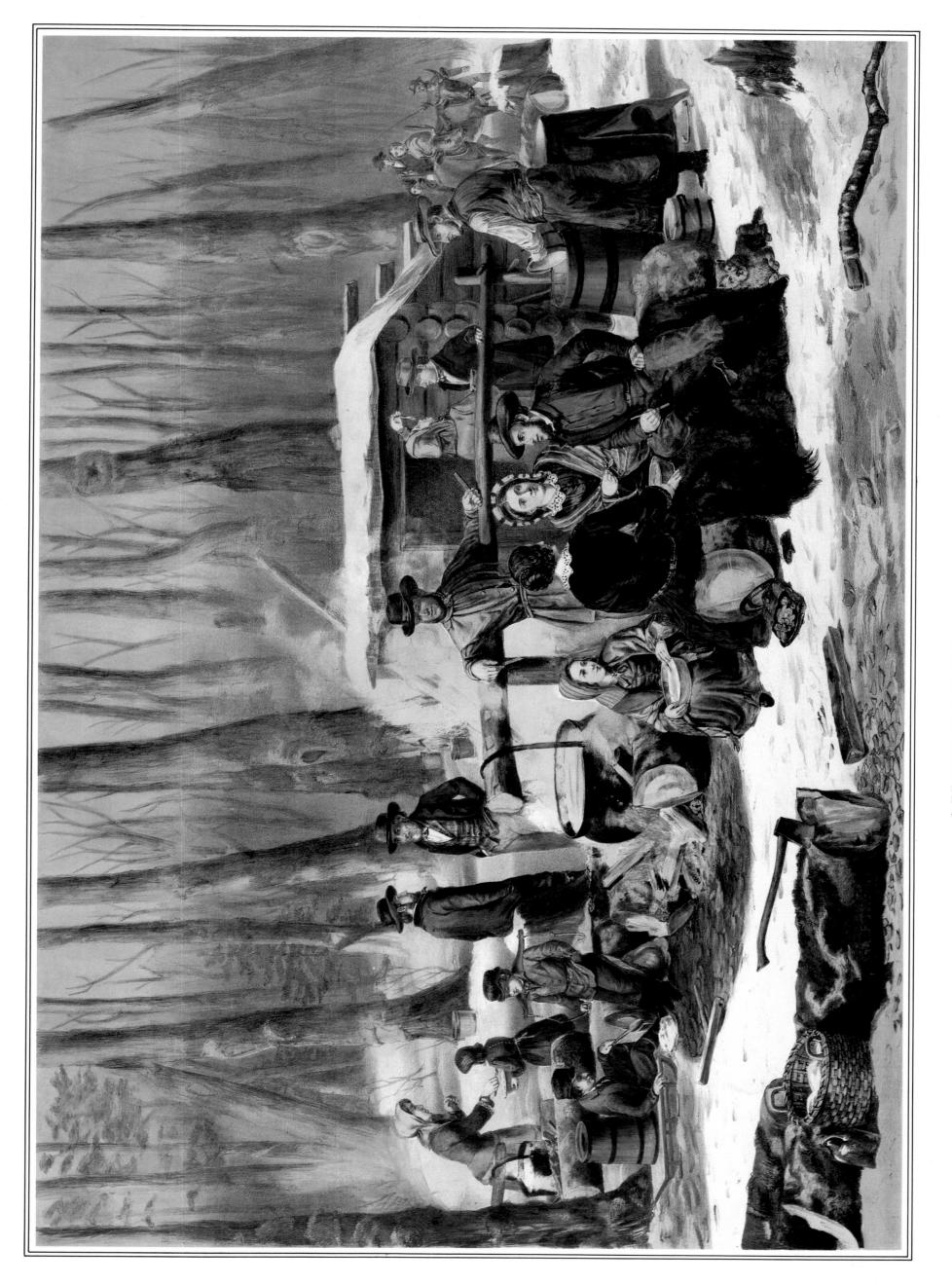

AMERICAN FOREST SCENE

WINTER IN THE COUNTRY

Getting Ice

THE CUTTING AND STORING OF river and lake ice was an important winter chore of the nineteenth-century American farmer. The blocks, kept for his own use, were hauled off to an ice shed where, packed in sawdust, they would keep throughout the year. Ice, cut for selling, was first transported in 1799, when blocks were shipped from New York to Charleston, South Carolina. During the 1800s it was shipped to many southern cities and even to countries as distant as India, packed in layers of straw in the holds of fast clipper ships.

Ice from Rockland Lake in New York was a common sight in New York City, where street criers sold it from their wagons. In *Cries of the Metropolis or, Humble Life in New York* (1857) there is an illustration of such an ice cart with the verse: "Ice! Ice! if you please, from Rockland Lake, / Whose cold water clear your thirst will slake; / Now here's a nice chunk for a penny a pound, / The finest of ice that was ever brought round."

Some historians have thought that this fine print, based on the work of George H. Durrie, shows ice cutting at Rockland Lake. However, there are at least fourteen paintings done by Durrie between 1861 and his death in 1863, the majority of which are identifiable as New England scenes. Since he was living in Connecticut during this time, it is more probable that this 1862 scene (published by Currier & Ives in 1864) is also of New England rather than New York's Rockland Lake.

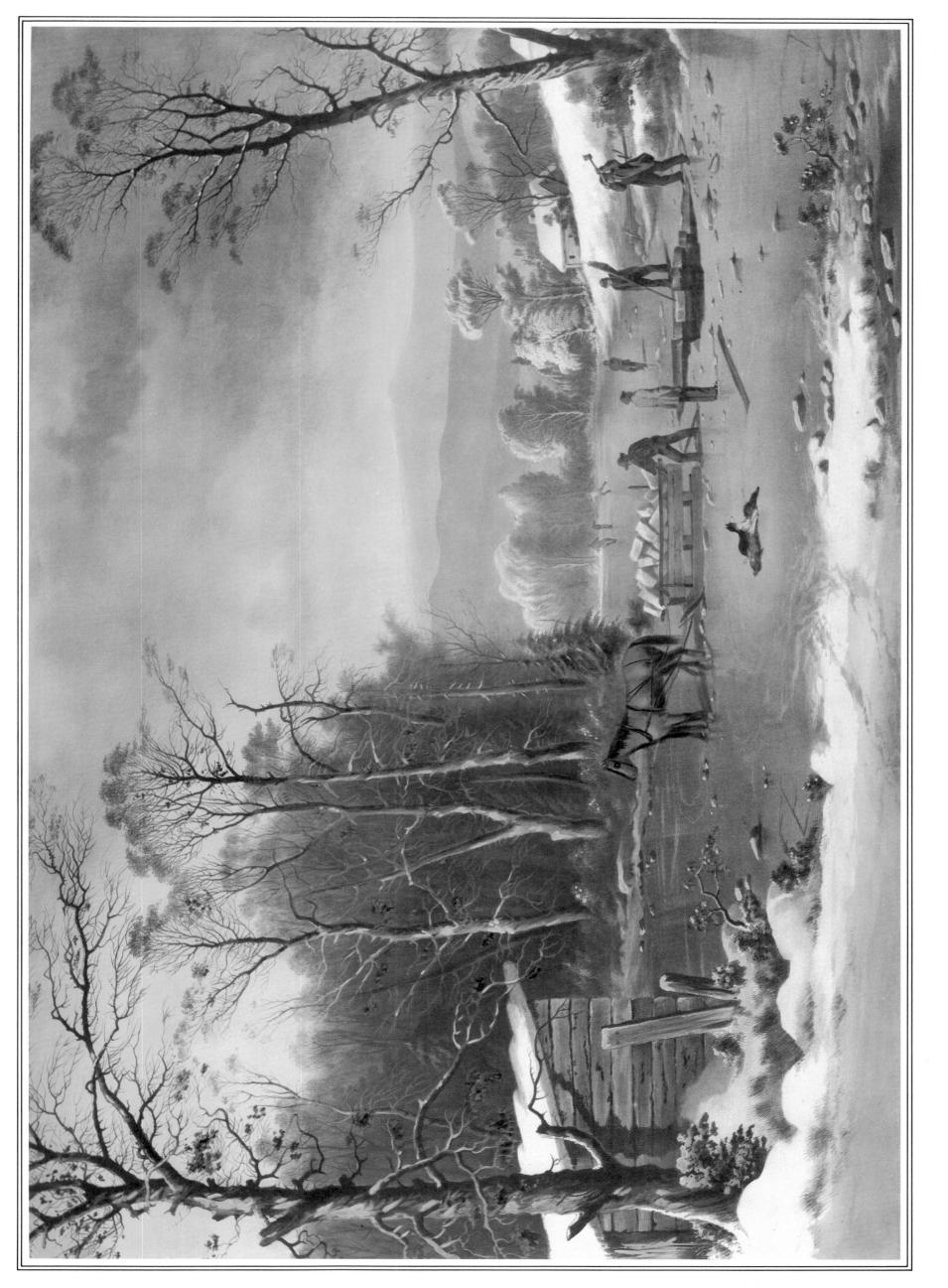

AMERICAN FARM SCENES. No. 4

IT IS SAFE TO SAY that more Christmas cards have been made from Currier & Ives prints over the years than from any other single source. Therefore it is ironic that the firm did only two subjects relating directly to Christmas. The Currier & Ives rural winter scenes, however, are a rich documentation of nineteenthcentury American life, particularly as it relates to New York and New England.

This print, based on the work of Frances ("Fanny") Palmer, has three companion pieces in large folio, covering the four seasons on the farm. But it is the winter one that is always the favorite. The horse-drawn sleigh with fur lap robes, neighbors skating on the pond, geese being plucked by the barn door, and the indication of the inviting warmth of an open fire in the farmhouse—these are all nostalgic reminders of a way of life that has become the American classic.

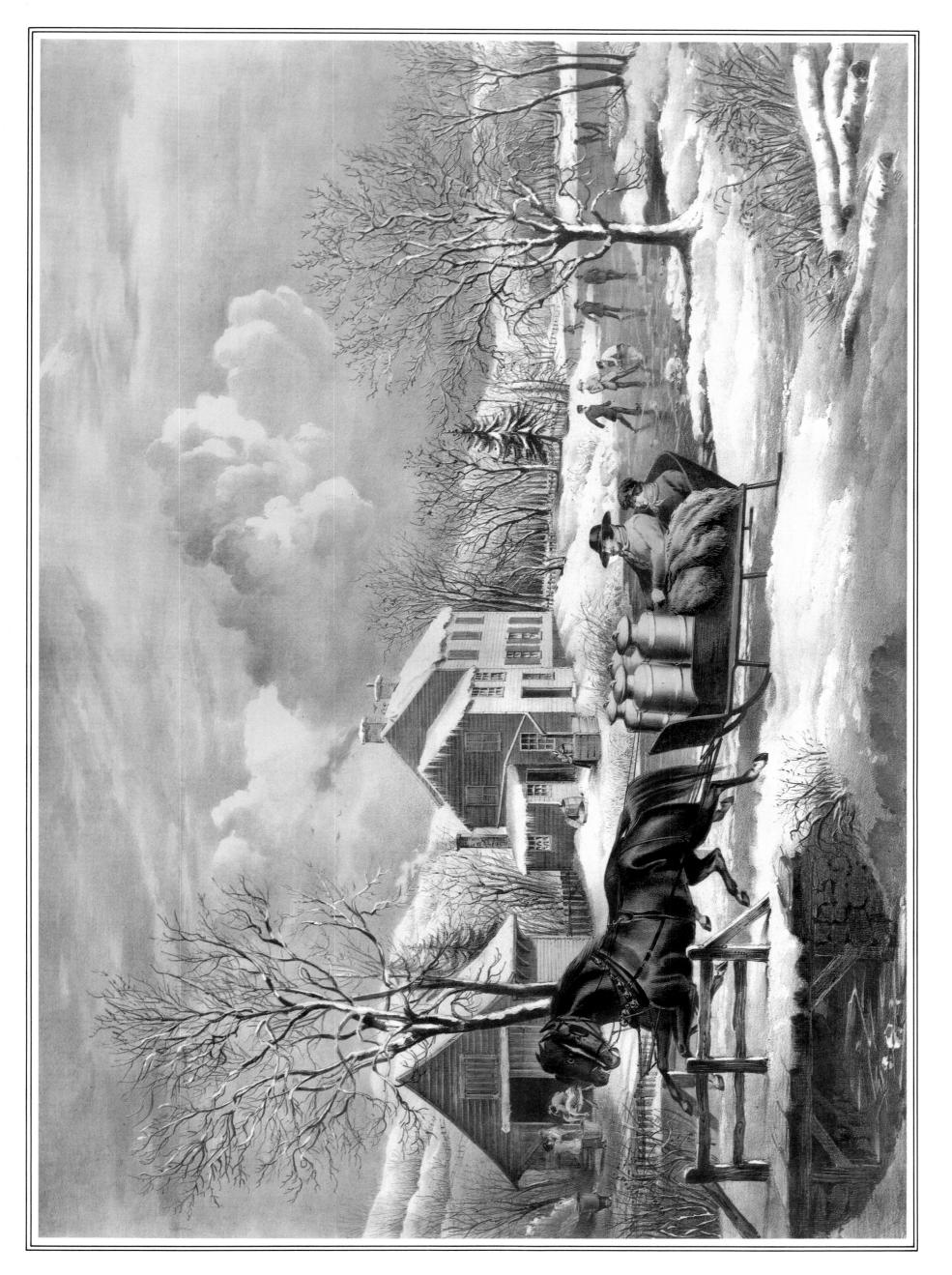

AMERICAN FARM SCENES

THE HIGH BRIDGE AT

HARLEM, N. Y.

WHEN AN ENGLISHMAN NAMED ALFRED PAIRPOINT came to New York in 1854, he visited Harlem and spoke of it as "one of the pleasantest suburbs." He crossed High Bridge, a "fine, modern stone bridge of many arches, the design of which does great credit to its architect."

This bridge, the first significant span over the waters surrounding Manhattan, was begun in 1839 and completed in 1848 as part of the extensive Croton Aqueduct System affording water for the city. Philip Hone wrote in his diary: "The present generation will overlook the enormous expense of this work and forget and forgive the extravagance in looking up at the lofty arches, and posterity, centuries hence, will justify, in regarding the stability of its construction, the expense of a million which it has cost."

High Bridge still stands today, crossing the Harlem River near West 173rd Street, but it is so altered as to be barely the same structure. To avoid danger to navigation, a single steel span was constructed in 1927-28 to replace the stone piers in the river.

Artists have long found this structure a favorite. N. Currier published the lithograph shown here in 1849, depicting the bridge in the bucolic setting of its early days.

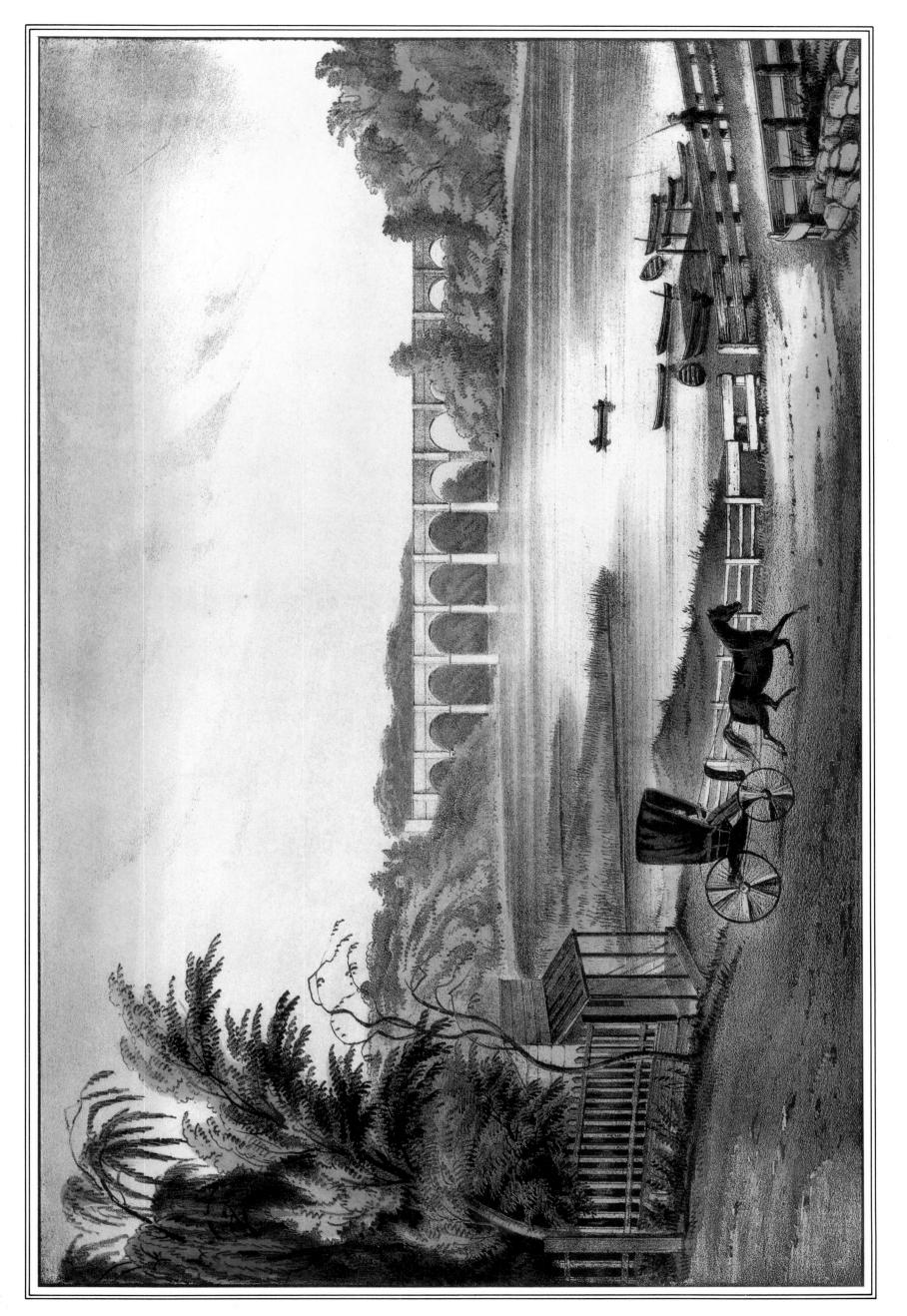

The HIGH BRIDGE AT HARLEM, N.X.

THE GRAND DRIVE, CENTRALPARK, N.Y.

As HENRY HOPE REED, curator of Central Park, stated in 1967: "Of all the city's wonders, Central Park ranks first in the affection of New Yorkers." Designed in 1858 by Frederick Law Olmsted and CalvertVaux, this remarkable park of 840 acres in the middle of Manhattan is wholly man-made. Before their "Greensward plan" was implemented, the area was little more than a barren wasteland with outcroppings of rocks its primary feature.

More than a hundred years before Reed's statement, the English novelist Anthony Trollope wrote after his travels here: "But the glory of New York is the Central Park; its glory is in the mind of all New Yorkers of the present day. The first question asked of you is whether you have seen the Central Park, and the second is as to what you think of it. It does not do to say simply that it is fine, grand, beautiful, and miraculous. You must swear by cock and pies that is more fine, more grand, more beautiful, more miraculous than anything else of its kind anywhere."

Seven years after this tribute, Currier & Ives brought out this print of the pedestrian and carriage paths in the park near East 64th Street with the old Arsenal in the background. In 1933, the print reproduced here from the Harry T. Peters Collection of the Museum of the City of New York was the only known colored impression.

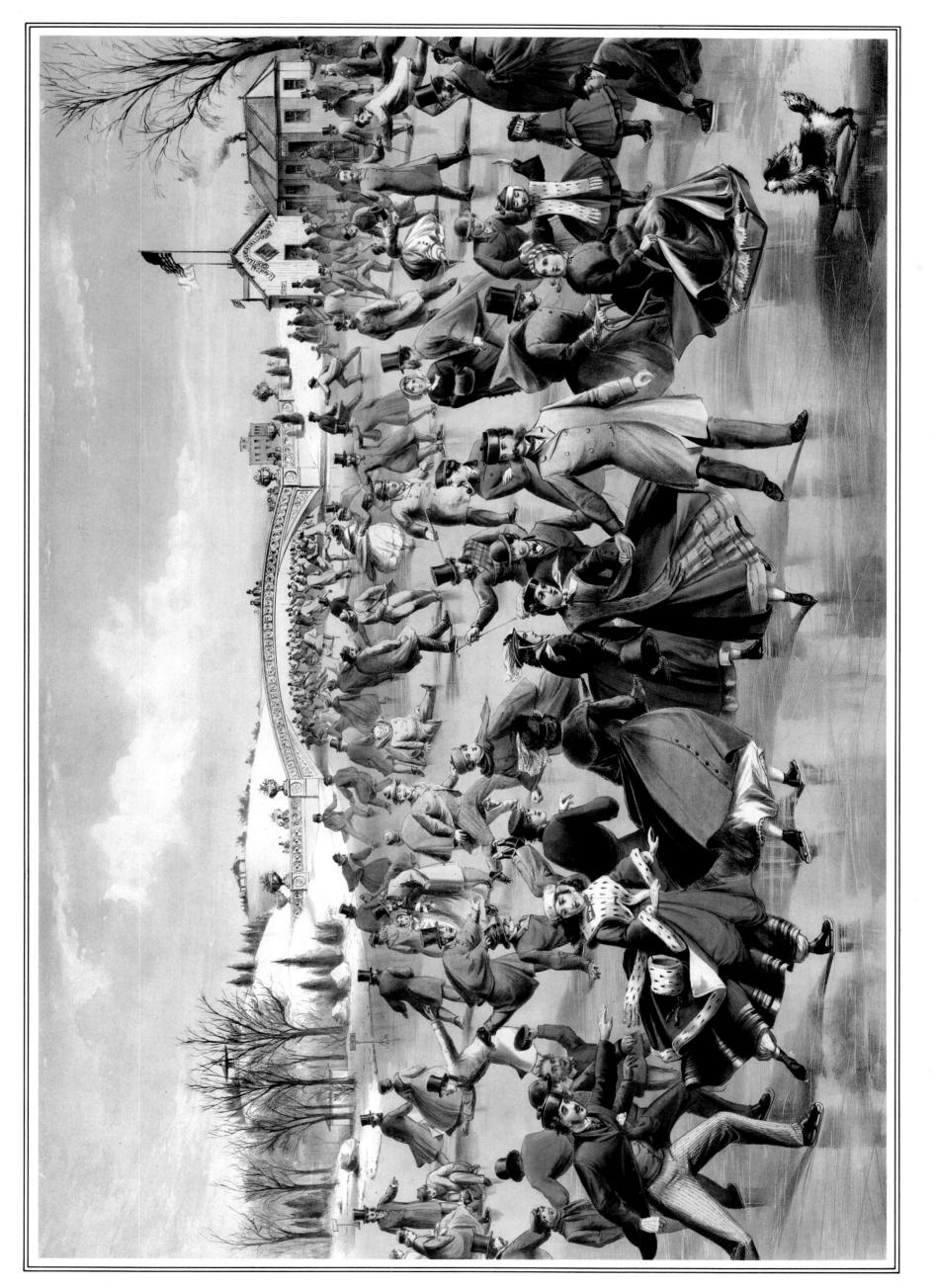

CENTRAL-PARK, WINTER

NEW YORK CRYSTAL PALACE

For Exhibition of the Industry of All Nations

INSPIRED BY THE LONDON CRYSTAL PALACE of 1851, New York built a similar structure the following year for America's first World's Fair entitled "Exhibition of the Industry of All Nations." This remarkable structure of iron and glass stood on the present site of Bryant Park, east of Sixth Avenue between Forty-first and Forty-second streets.

Touted as being completely fireproof because of the building materials used, the New York Crystal Palace was totally destroyed by fire on October 5, 1858. The heat of the fire, which started on the inside, melted the glass and allowed the flames to roar through. No fewer than two thousand persons were estimated to have been in the building at the time but no lives were lost despite the fact that nearly the whole structure burned to the ground in twenty-one minutes.

The tall building on the left in this 1853 lithograph is the Latting Observatory, constructed of timber braced with iron and measuring three hundred feet high—probably the tallest edifice erected in America up to that time. Designed by Waring Latting, it featured a steam elevator to the second landing, where there were telescopes for viewing the panorama of the city. The observatory burned down in 1856.

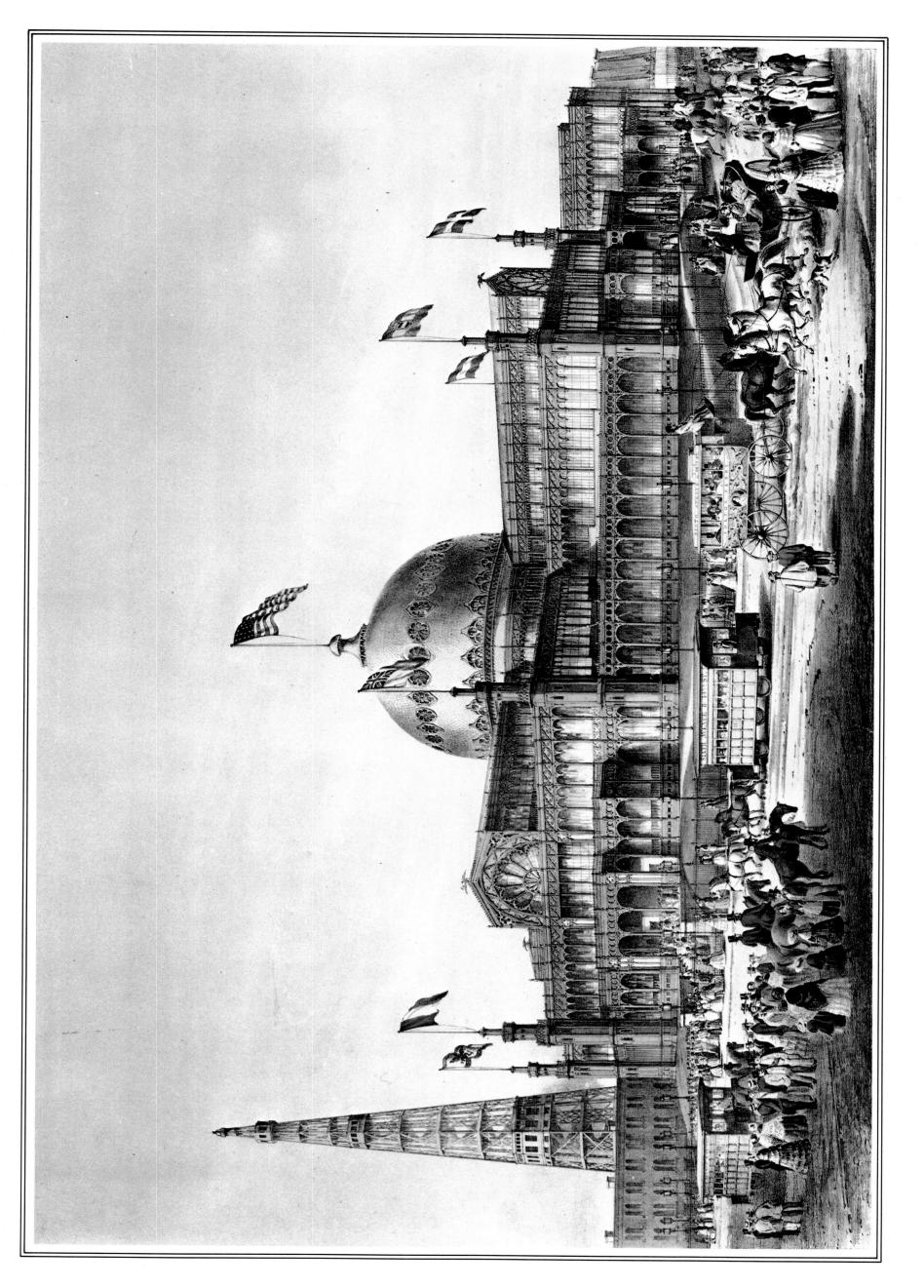

NEW YORK CRYSTAL PALACE

THE LIFE OF A FIREMAN

The New Era., Steam and Muscle

ALTHOUGH THE BEGINNING of the New York Fire Department really dates from 1648, when Governor Peter Stuyvesant appointed four fire wardens, an organized system of volunteers was put into effect in 1737. The act appointed "a Sufficient Number of Strong able Discreet honest and Sober Men."

The Volunteer Fire Department saw many changes and improvements in equipment over the years, but when the steam engine was given a successful trial in 1841, the firemen stubbornly clung to their hand pumpers, fearing that the new engines would thin their ranks. By 1861, the date of this print, more and more steam engines were being placed in service. Steam saved a good deal of man power, which could be used in more serviceable directions. Buildings were being erected with higher stories and steam engines were able to throw steadier and higher streams of water to reach into the burning upper floors. Here are two steam engines of the period; in the background is an old hand pumper vying for superiority. The scene is taking place at the corner of Murray and Church streets with City Hall in the distance.

The New York Volunteer Department was disbanded in 1865, and the Metropolitan Fire Department was established. The modern era of New York fire fighting had thus begun. Gone were the exciting, colorful days of the fire laddies.

In the important series of "The Life of a Fireman," four were issued in 1854, this one in 1861, and one showing the Metropolitan system in action in 1866.

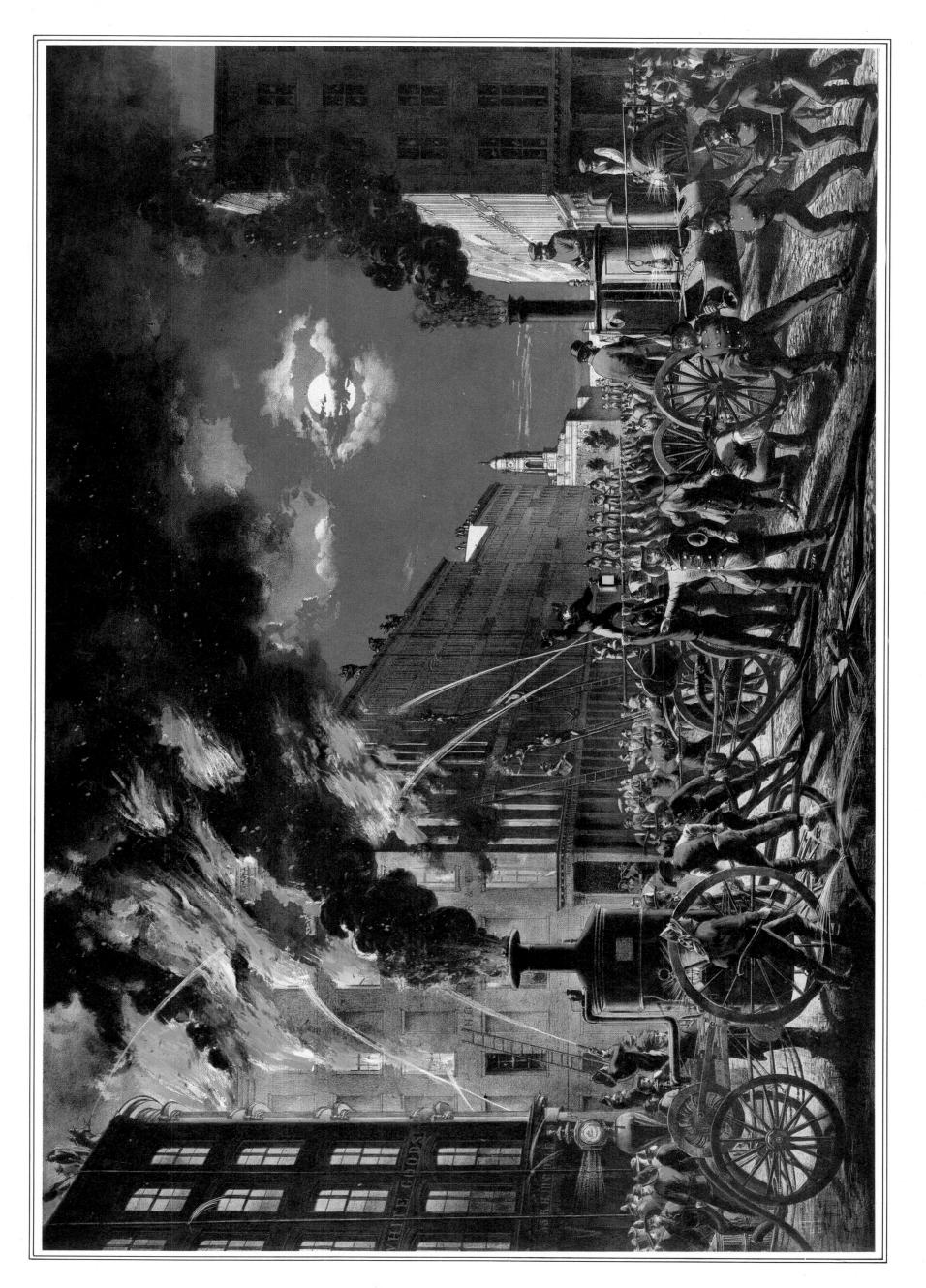

THE LIFE OF A FIREMAN

THE GREAT FIRE AT CHICAGO,

October 8th 1871

THE FIRE WHICH BEGAN IN CHICAGO on the Sunday evening of October 8, 1871, is probably America's most famous. Legend has it that when Kate O'Leary went to the hay-filled barn to milk the cow, the latter, annoyed at the lateness of milking, kicked the kerosene lantern off the stool and set the blaze. During the next thirty-one hours nearly the entire city was destroyed with a loss of life of about 500 persons, 100,000 left homeless, and damage estimated at \$200,000,000.

Whether or not a cow was involved, the fire did start in the poorer Irish neighborhood in which Mrs. O'Leary lived. Circumstances could hardly have been worse: rainless weeks had left the predominantly wooden structures tinder dry; a large fire the previous night had injured 30 of the 185 firemen on the force; firemen were still exhausted and equipment needed repair. To compound the danger, gale-force winds blew. The Reverend E. J. Goodspeed described the fire's spread: "A perfect hurricane was blowing, and drew the fiery billows with a screech through the narrow alleys between the tall buildings as if it were sucking them through a tube; great sheets of flames literally flapped in the air like sails on shipboard." As to the state of the people, he said in part: "They stumbled over broken furniture and fell, and were trampled under foot. Seized with wild and causeless panics they surged together backwards and forwards in the narrow streets, cursing, threatening, imploring, fighting to get free."

Although many felt the city could never be rebuilt, others vowed to make Chicago even better and stronger than before. By the first anniversary of the fire, half the city had been built and by 1875 few traces of the Great Fire remained.

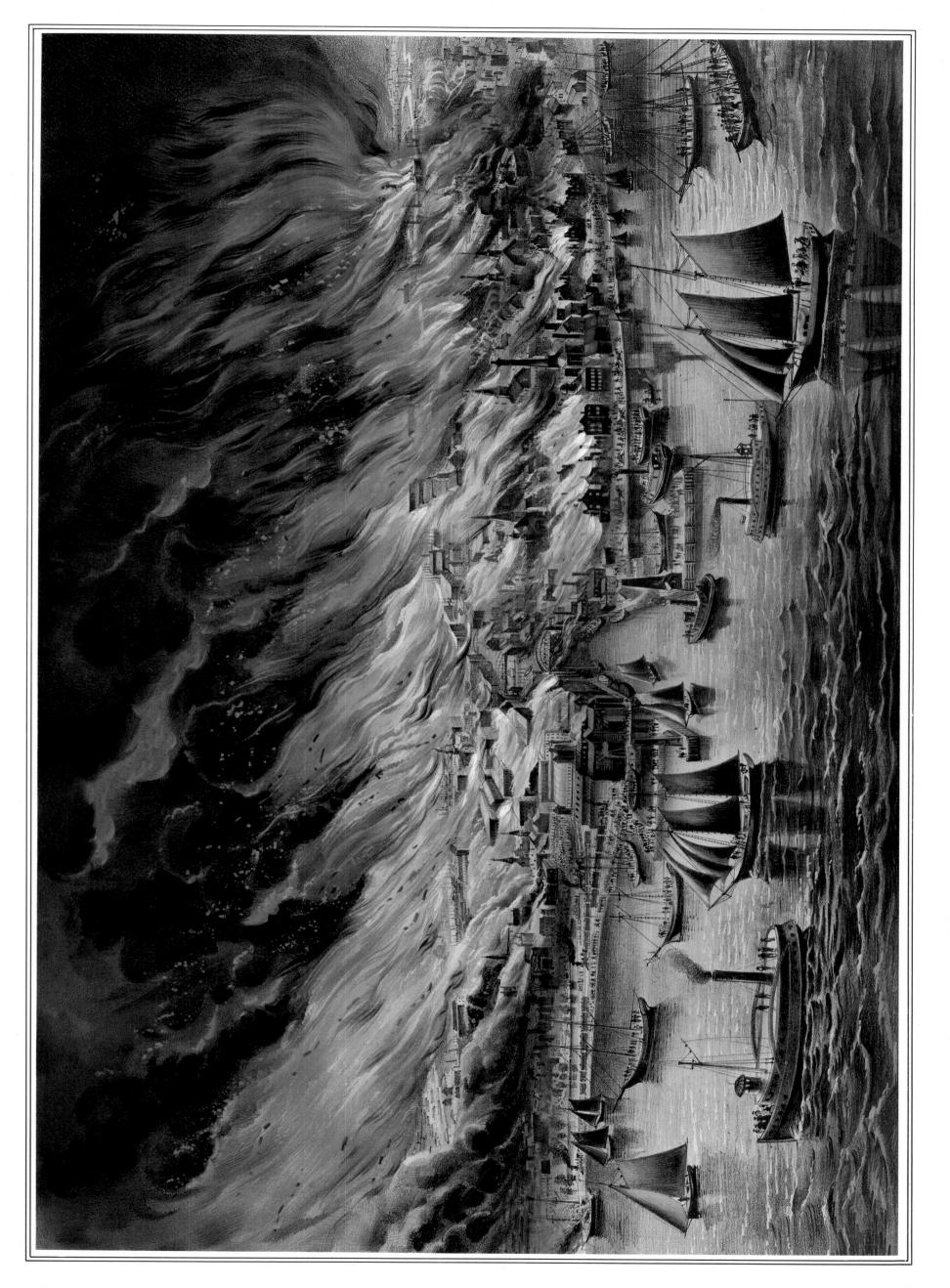

THE GREAT FIRE AT CHICAGO, OCT. STH, 1871

THE "LIGHTNING EXPRESS" TRAINS

"Leaving the Junction"

THE EXCITEMENT OF RAILROADS captivated America from their first beginnings in the 1830s. This whole development occurred during the lifetime of Nathaniel Currier. It is therefore not surprising that the firm issued about thirty dramatic prints relating to this subject. The first was in 1853 entitled American Express Train and the last was Night Scene at the Junction in 1884.

Frances ("Fanny") Palmer, the artist of this 1864 print, not only delineated each detail of the locomotives and the cars with great accuracy but also played up the drama of this moonlight scene with the onrushing engines spewing out the burning sparks from the wood fuel. It is believed that this is a depiction of the trains of the Hudson River Railroad. This railroad, dominated by Cornelius Vanderbilt, was his chief instrument in gaining control of the great New York Central when they merged in 1869.

The Currier & Ives railroad prints are collector's items, not only because of their lithographic quality but also because of the vast number of railroad buffs who recognize in them the fine documentation of their favorite subject.

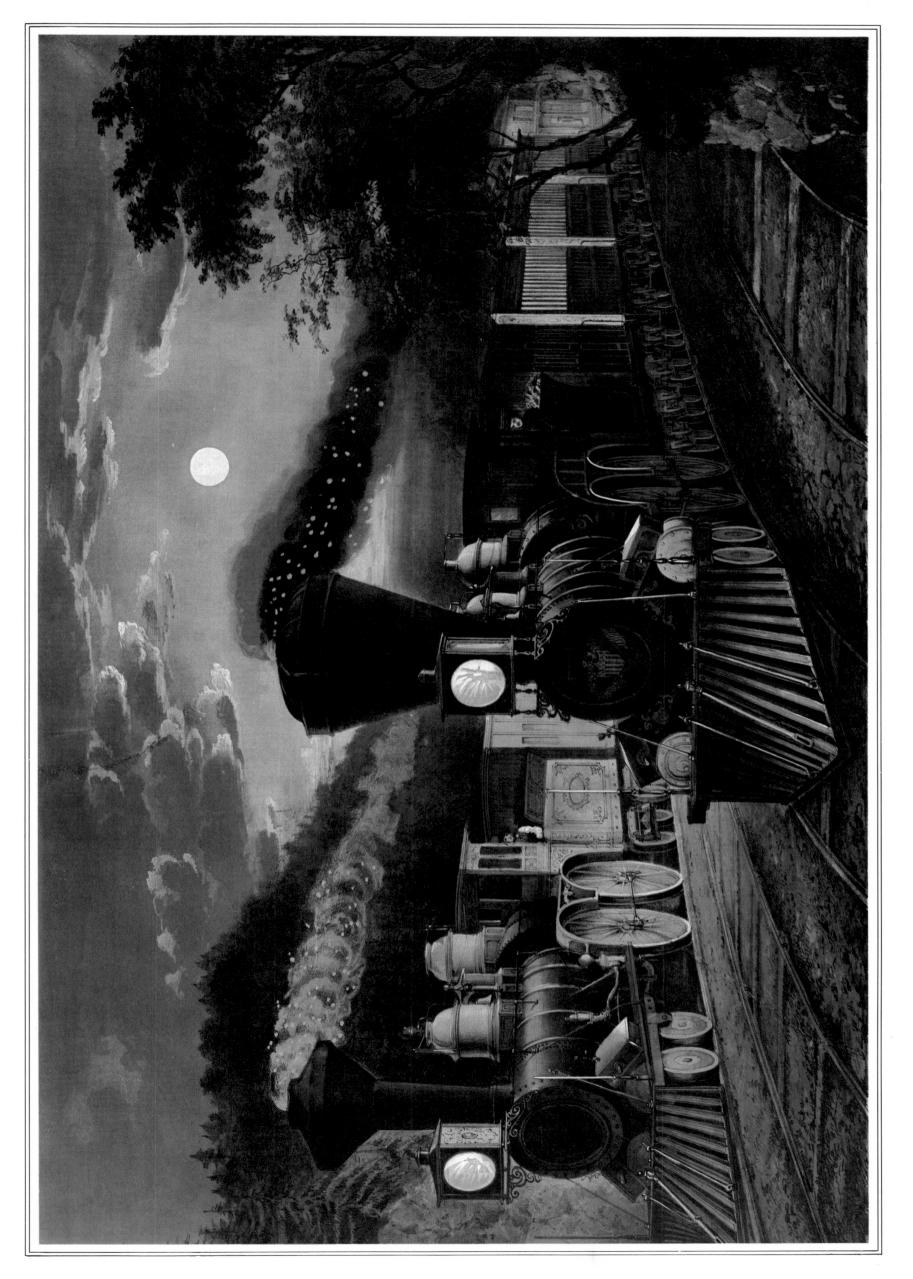

THE **LIGHTNING EXPRESS* TRAINS

ACROSS THE CONTINENT

"Westward the Course of Empire Takes its Way"

THIS LITHOGRAPH IS REPRODUCED in more encyclopedias and American history texts than any other work by Currier & Ives. Fanny Palmer and James M. Ives, the creators of this print in 1868, filled the scene with romantic allusions associated with the settling of the West: "cheerful pioneers" clear the land and build their tidy log cabins; a schoolhouse is prominent in the foreground; there are covered wagons, buffalo (as late as 1890 signs were posted in western trains forbidding passengers to shoot game from the car windows), and, of course, the curious but friendly Indians. Shortly, the Union Pacific Railroad, shown here, would join with the Central Pacific at Promontory Point, Utah, to span the continent.

It is curious that the subtitle, so pertinent to this scene, is taken from a work by the eighteenth-century Irish bishop and philosopher, George Berkeley, entitled Verses On the Prospect of Planting Arts and Learning in America.

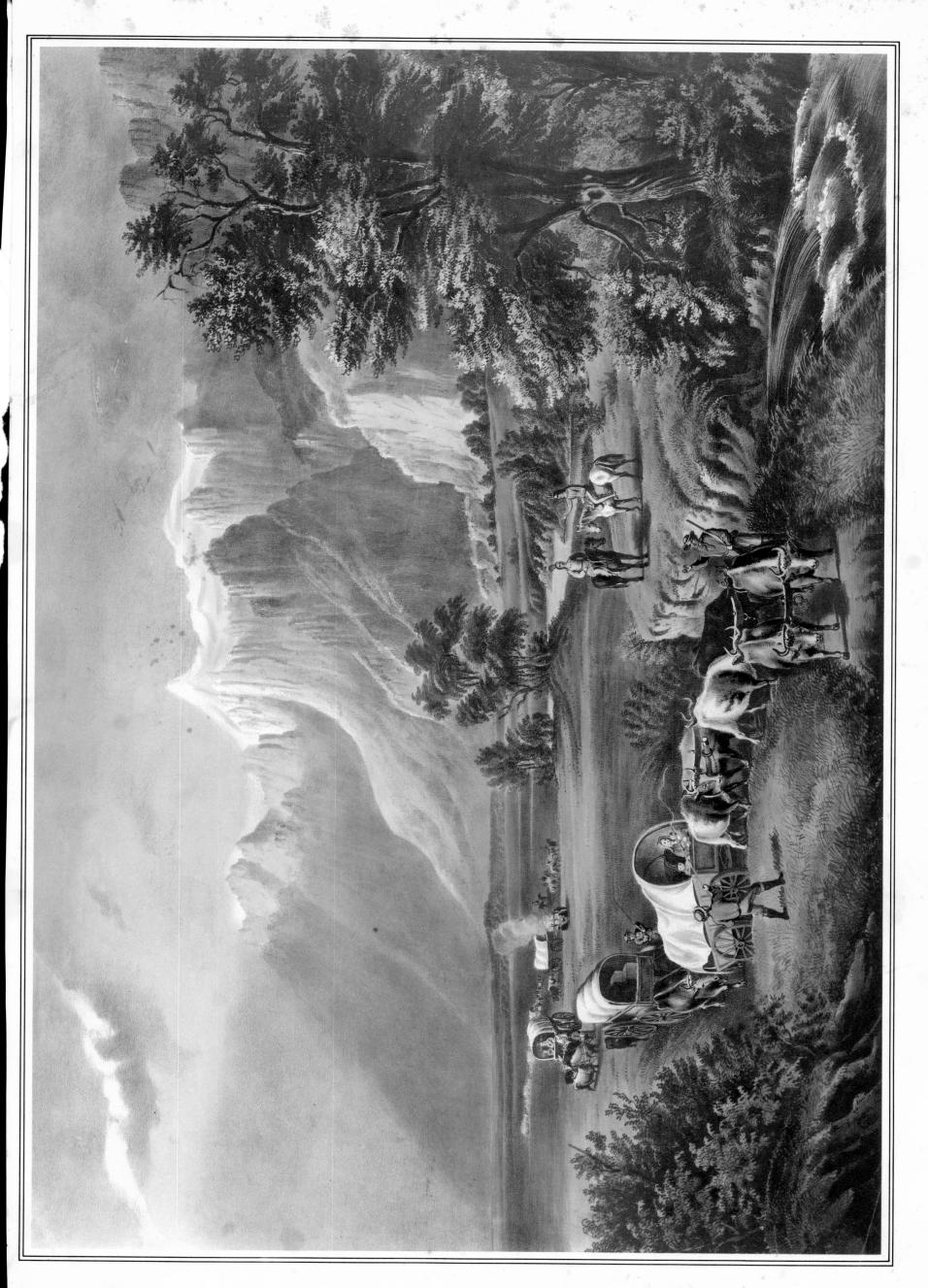

THE ROCKY MOUNTAINS--EMIGRANTS CROSSING THE PLAINS

LIFE ON THE PRAIRIE

The Trapper's Defense., "Fire Fight Fire"

ARTHUR FITZWILLIAM TAIT, like most of the artists who worked for Currier & Ives, never saw the West but arduously studied the work of important painters who documented the western scene, particularly Karl Bodmer. In this way Tait was able to capture all the feeling of danger and excitement so closely associated with life on the western prairie. The romance of the West gripped the imagination of the rest of the country. Philip Hone had said in his diary: "Killing buffaloes, hunting wild horses, sleeping every night on the ground for a whole month, and depending from day to day for means of existence upon the deer, wild turkey and bears . . . are matters of thrilling interest to citizens who read them in their green slippers seated before a shining grate."

In this 1862 scene the three hunters and trappers are desperately trying to escape from the great fire sweeping in from the left by attempting to stem the onrushing flames by means of a firebreak. Fires were a constant threat on the prairie. It was common for Indians to set fires to drive the buffalo—a herd can be seen stampeding in the distance. Sparks from locomotives or even lightning were able to ignite the dry grass.

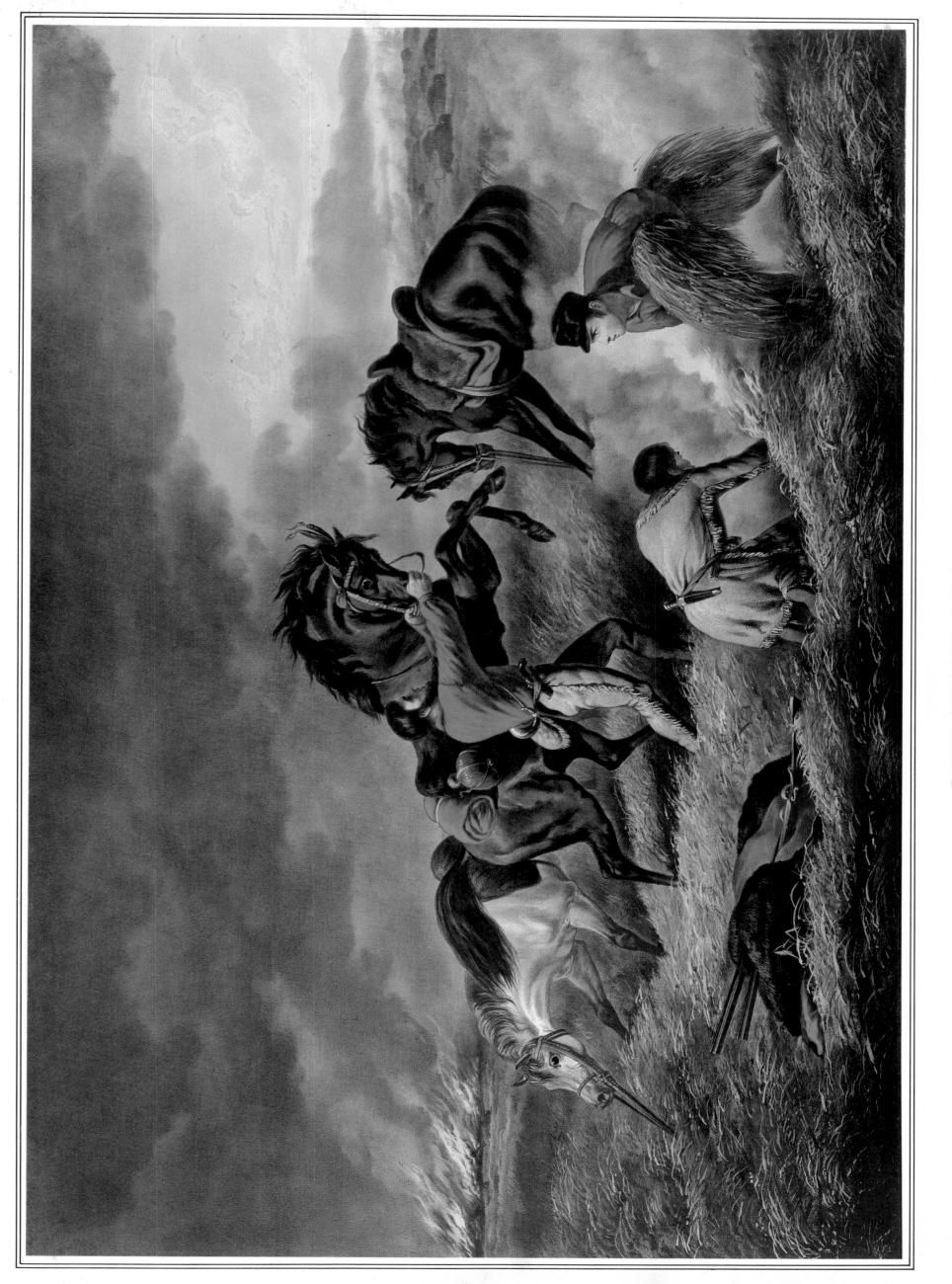

LIFE ON THE PRAIRIE

THE SNOW, SHOE DANCE

To Thank the Great Spirit

for the First Appearance of Snow

EVEN IN HIS YOUTH the artist George Catlin was fascinated with stories about the American Indian. He announced: "The history and customs of such a people, preserved by pictorial illustrations, are worthy the life-time of one man, and nothing short of the loss of my life shall prevent me from visiting their country and becoming their historian." Pursuing his determination, he set off in 1832, at the age of thirty-six, to study these Indians. For the next seven years he traveled from the Rocky Mountains to South Carolina, Florida, Texas, and the Canadian border, painting about six hundred scenes of Indians and their daily life.

In his writings, from which Currier & Ives took excerpts for their 1860 catalogue, he said of the Chippewa ceremony shown here: "In northern America, the winters are long and severe, from heavy falls of snow, and the Indians have very ingeniously constructed a large but light frame, with a fine webbing made of small thongs of raw hide, which is worn under the foot, buoying them up, and enabling them to run upon the surface of the snow without sinking into it. These they call Snow Shoes; and as they enable them to overtake the heavy animals with great ease, their hunting facilities are materially increased by an accumulation of snow; and at its first appearance they celebrate the event by a dance, with a song of thanks to the Great Spirit, 'who has sent it for their benefit.'"

There is some question as to how Currier & Ives, who, between 1857 and 1860 issued some nine lithographs based on Catlin's work, obtained the sources. The first Catlin lithographs were published in England in 1844. The following year the socalled American edition was put out by J. Ackerman. The fact that the Currier & Ives prints have a different "look" from most of their work and were published without date or copyright many years later deepens the puzzle.

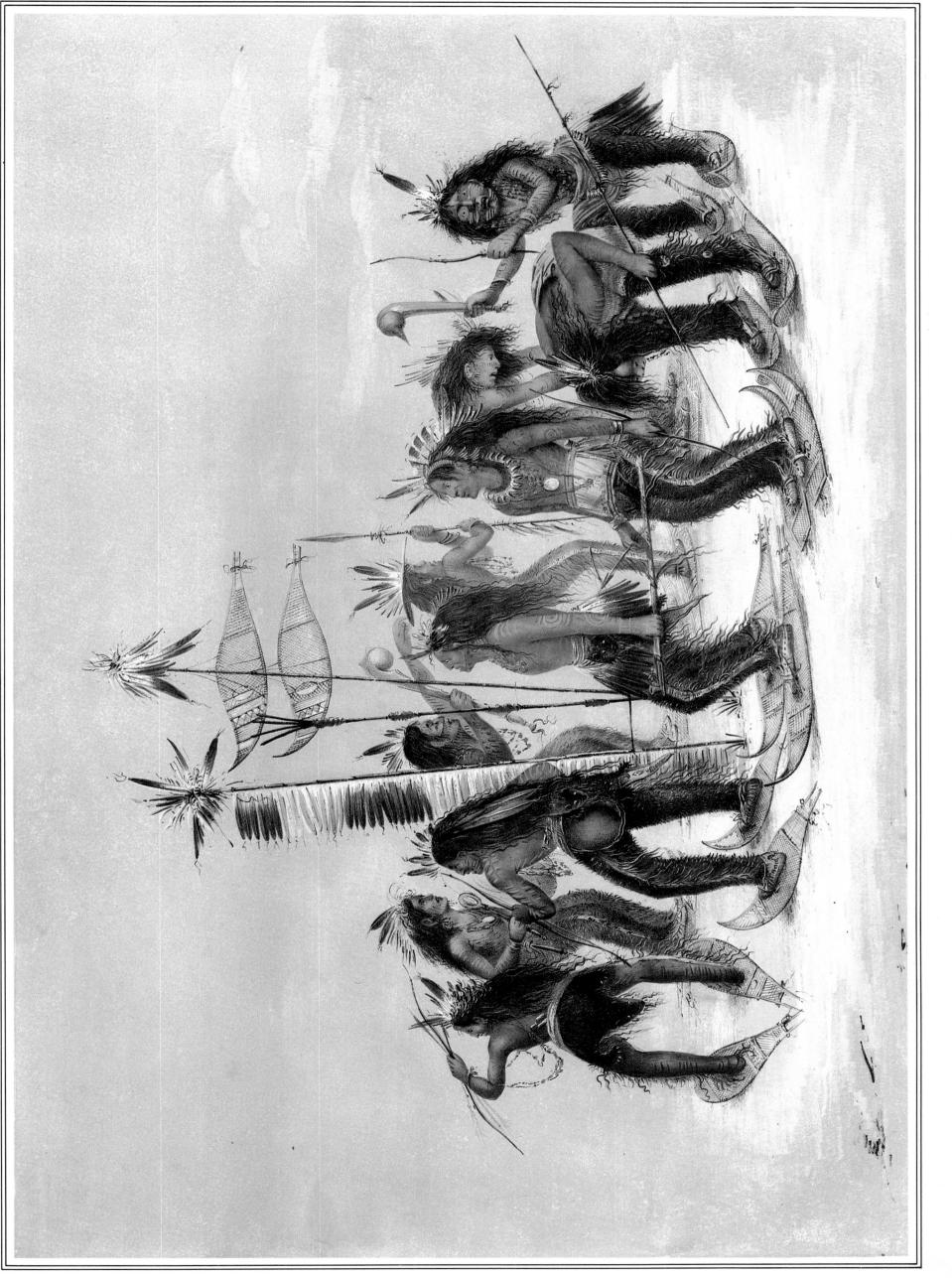

THE SNOW-SHOE DANCE

CLIPPER SHIP "NIGHTINGALE"

Getting Under Weigh Off The Battery, New York

BASED ON THE WORK OF JAMES E. BUTTERWORTH, one of America's outstanding marine painters, this print faithfully captures the grace and romance of the great era of the clipper ship in the mid-nineteenth century. The *Nightingale* was launched in 1851. The previous year Jenny Lind, who was called the "Swedish Nightingale," had made her celebrated American debut at Castle Garden in New York City. It was for this famous soprano that the ship was aptly named. Even a figurehead of Miss Lind graced the bow. It is fitting that in this print the shoreline of Manhattan includes Castle Garden as the most prominent building.

Octavius Howe and Frederick Matthews, in their book American Clipper Ships, wrote: "The extreme clipper ship NIGHTINGALE was one of the most beautiful, as she was certainly the most interesting, of any of the ships built during the clipper era. Her story, were all the facts known, would be as romantic and exciting as anything in marine fiction. Constructed with all the finish and luxury of a yacht; launched under a load of debt which necessitated an early sale at auction; a pioneer to the gold fields of Australia; a winner in the English tea races; a slave ship, war vessel and California clipper, the NIGHTINGALE, wherever she went, excited admiration and interest."

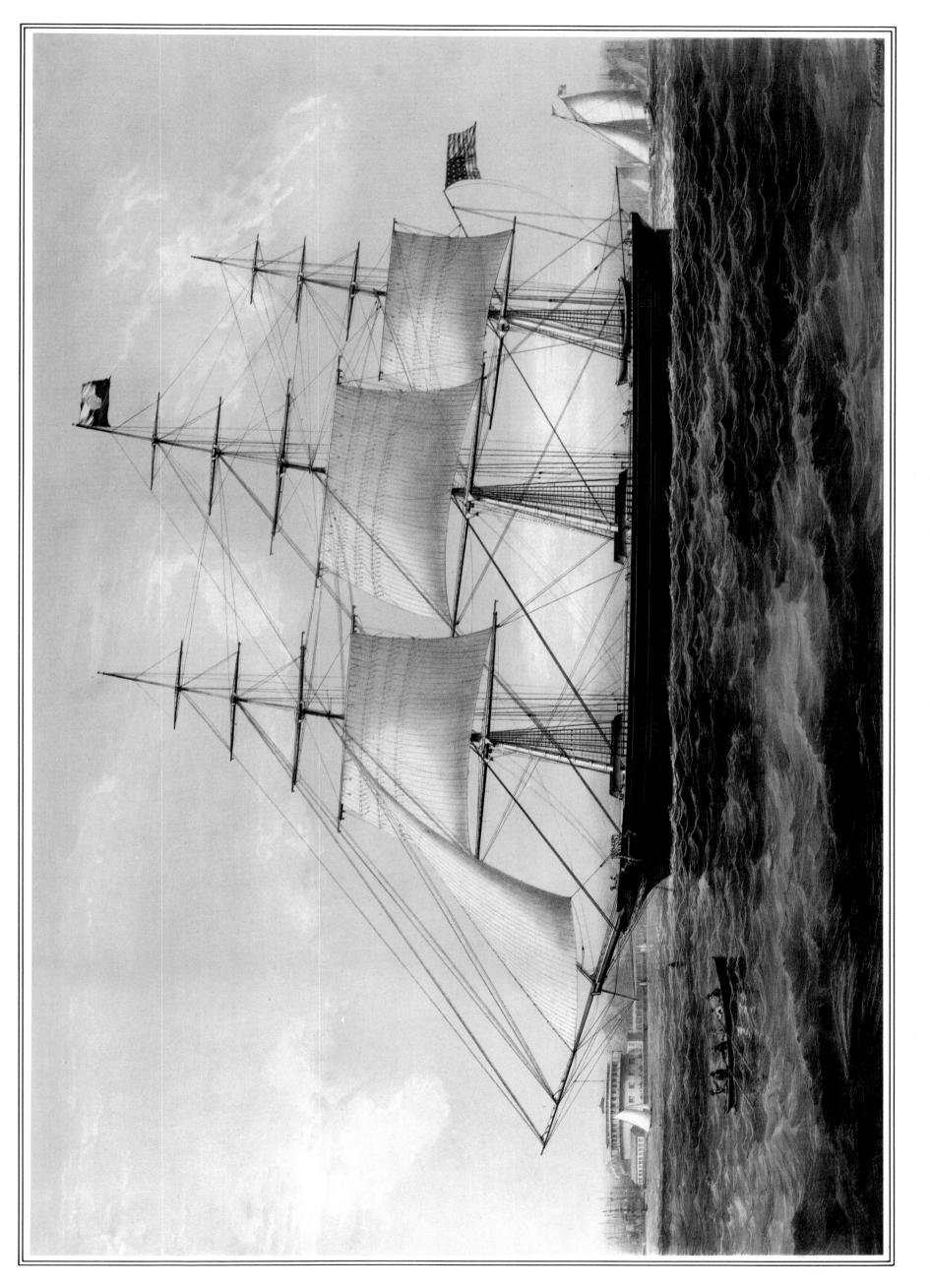

CLIPPER SHIP ** NIGHTINGALE**

THE CLIPPER YACHT "AMERICA"

of New York

Winner of "the Cup" in the Great Match for all Nations at Cowes, August 22nd, 1851.

BRITAIN WAS A PROUD NATION as she hosted the 1851 Great Exhibition, the first World's Fair. Captains of industry were founding vast fortunes and clipper-ship captains were setting new records. Against this background a group of members of the New York Yacht Club, which had been organized in 1844, decided to show the world what a fine vessel the pilot-boat yacht really was. The syndicate headed by Commodore John C. Stevens and George L. Schuyler commissioned George Steers to design and build their yacht. She was to be called the *America*.

Hoping for a stake in the neighborhood of ten thousand guineas, the Royal Yacht Squadron was challenged. Such a stake was not forthcoming, but the squadron offered as a prize a onehundred-guinea silver cup. On August 22, 1851, the *America* raced against fourteen yachts on a sixty-mile course around the Isle of Wight in England. The *America* won easily—so easily, in fact, that tradition has it that when Queen Victoria asked which boat was second, she was told: "There is no second, Your Majesty." The cup has remained in the possession of the New York Yacht Club without interruption in spite of twenty-three challenges by British and Australian yachts.

Very shortly after the race, N. Currier captured on stone the nation's most famous yacht. This lithograph is scarce and highly sought after.

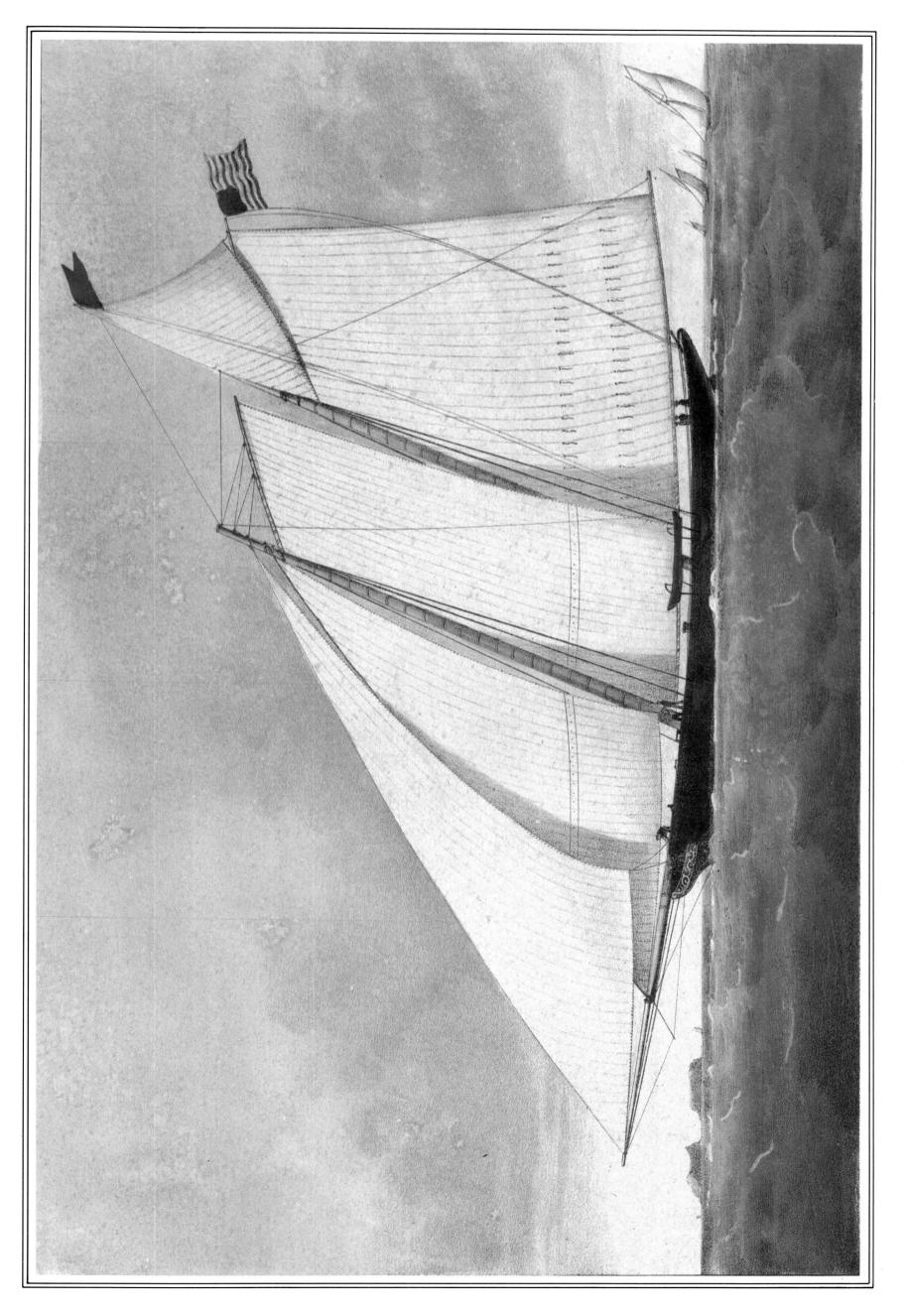

THE CLIPPER YACHT*AMERICA"

SUMMER SCENES IN NEW YORK HARBOR

IN THIS PLEASANT VIEW of New York harbor, the artist has attempted to include every type of vessel that might have been in these waters on a summer's day in 1869. They number thirtytwo in all; thirteen ships, seven small sailing craft, two racing shells, eight rowboats, and two harbor boats. It is fortunate that the wind is relatively calm-a strong breeze would have created much confusion in reality. Not only is there a variety in types but even in nationality of ship. Currier & Ives labeled the more important ones. At the left in the middle distance is a North German Lloyds steamship, closed by a French mail steamer, and, with a rather poorly drawn stern, a British war steamer (flying the American flag as was proper for such a visiting vessel). In the center distance are a Havana steamship, a Russian warship, and a packet ship. Nearer are a French frigate, a coastal steamer, a Long Island Sound steamboat, and a British royal mail steamship. A Hamburg steamship is almost obscured by a schooner yacht. At the right are a Pacific mail steamship, a U.S. frigate, and a pilot boat.

The center of interest is a crew race between two six-oared crews. Sixes and fours were common for some time before the general adoption of eight-oared crews. By the inclusion of Fort Lafayette in the Narrows and the hills of Staten Island to the right of the fort, the location of the scene is firmly set.

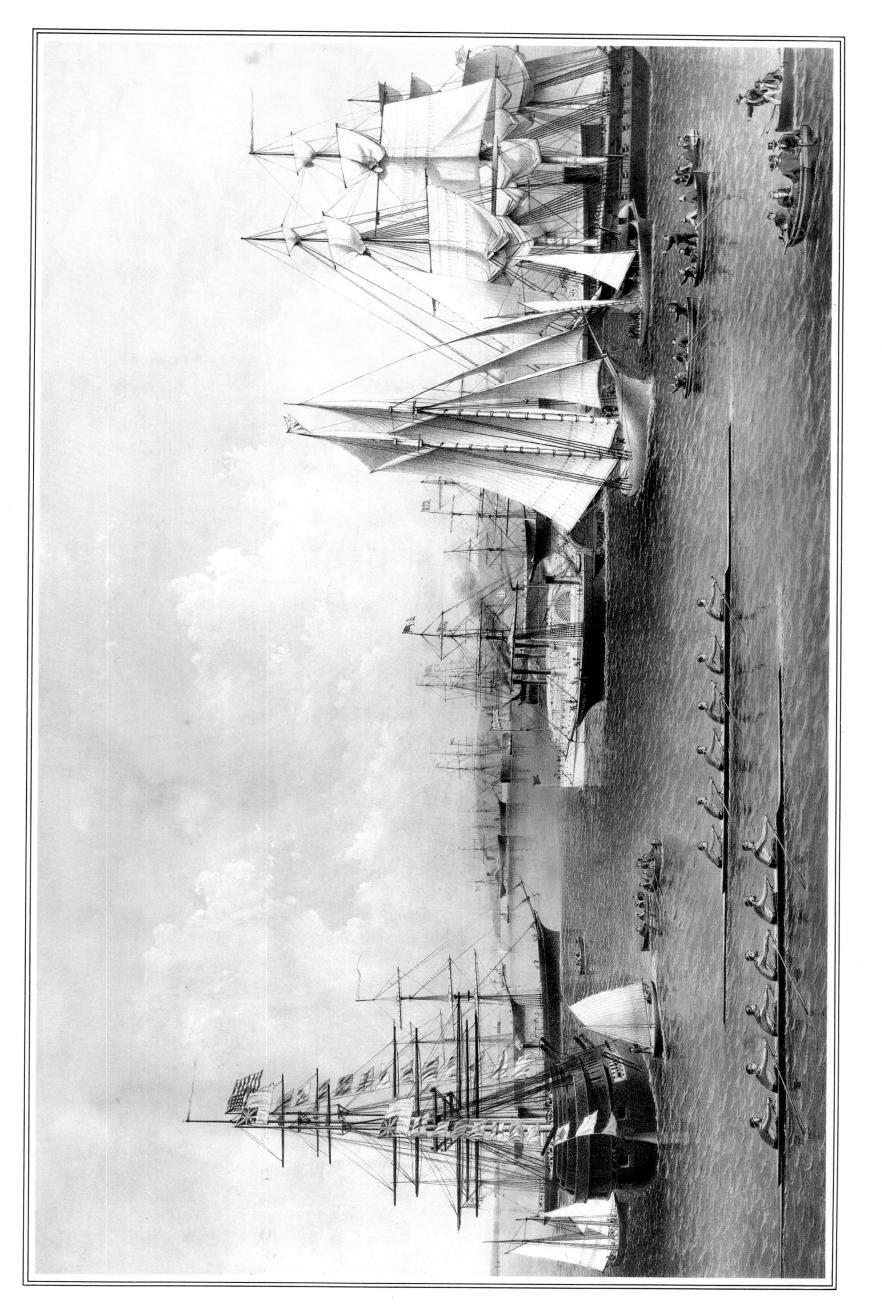

SUMMER SCENES IN NEW YORK HARBOR

THE WHALE FISHERY

THE CAPTURE OF WHALES for food dates from at least the fourteenth century. In many countries, whaling on a large scale did not begin until the seventeenth century, when the use of whale oil for lighting became so important. In America, southern New England became the whaling center, particularly Nantucket and later New Bedford. In 1846, the American whaling fleet numbered 736 vessels; eleven years later New Bedford alone had 329 whaleships.

The romance of whaling was deeply ingrained in the American spirit. The idea of six men rowing out in a small whaleboat to harpoon and kill the largest mammal extant had to capture the imagination. However, the life of whaling men was not an easy one. Usually they would be away for months at a time, often for as long as five years. Disease and accidents took their toll. Daily life on board was very harsh, and the stench of the blubber being rendered into oil after each catch was a fact one never became accustomed to. With the discovery of petroleum in Pennsylvania in 1859 and methods of refining it for lighting fuel, the need for whale oil became less vital, and the industry diminished markedly during the following years.

This print, one of eleven whaling subjects Currier & Ives issued, is based on an 1840 aquatint by Frederic Martens after the painting by Louis Garneray, a French marine artist who spent some time in America. Some years later the print was reissued in small folio format in a cruder and less dramatic rendering. Even in the later print the original designers were not given proper credit—a fairly common practice of nineteenthcentury lithographers. Most of the firm's whaling prints focused on the sperm whale, a ferocious quarry but one whose oil was much finer than the other species of whales.

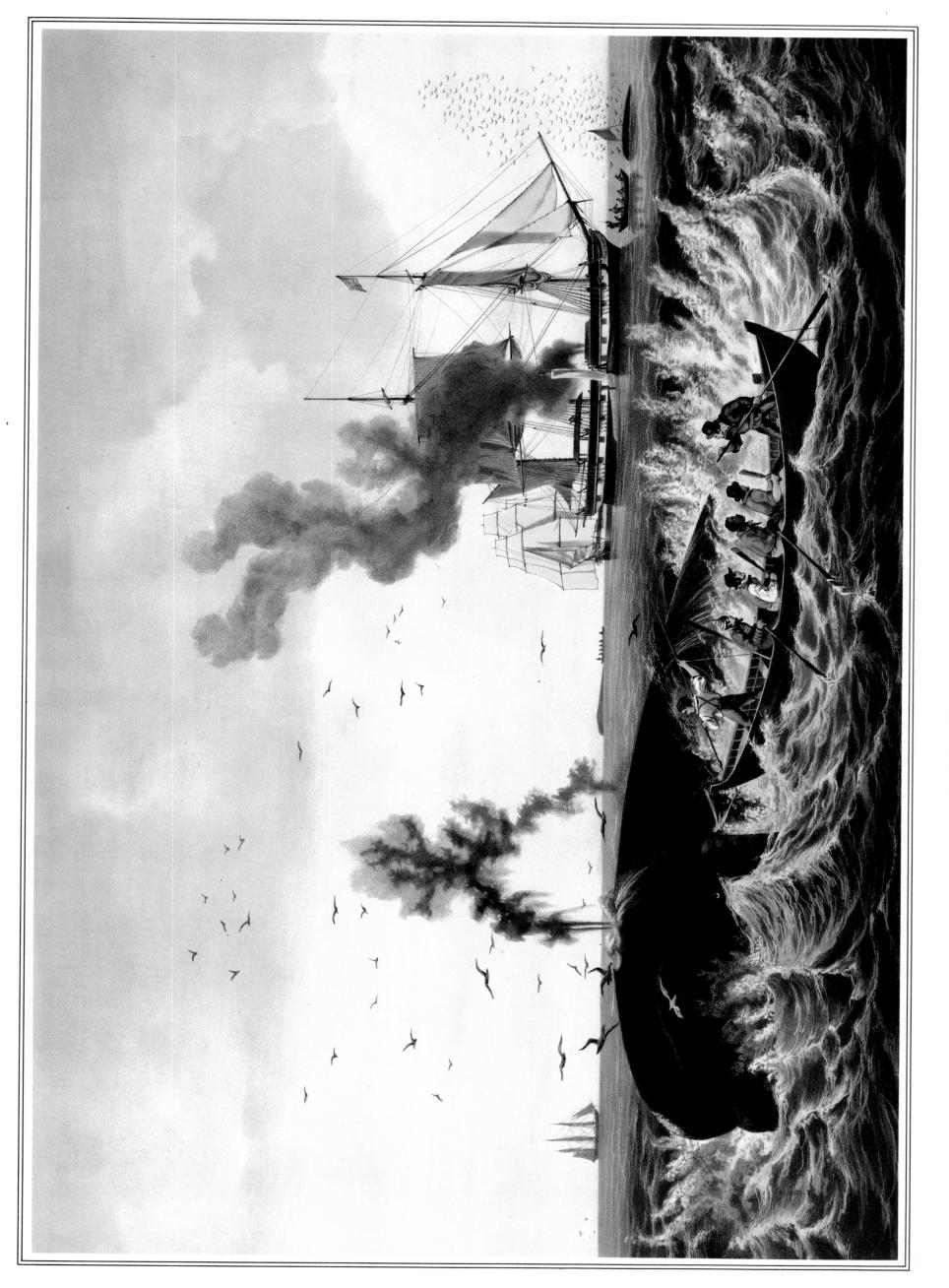

1

THE WHALE FISHERY

THE WRECK OF THE STEAM SHIP "SAN FRANCISCO"

BUILT BY WILLIAM H. WEBB for the Pacific Mail Steamship Line, the San Francisco left New York on her maiden voyage on December 22, 1853, bound for Cape Horn and the Pacific. She had been chartered by the government to transport the Third United States Artillery Regiment to California, there were five hundred officers and men with wives and children. With the addition of eight hundred tons of coal, she was overloaded but at least the weather seemed auspicious. Thirty-six hours out of port, however, she ran into a storm in the Gulf Stream which grew in intensity and by Christmas day was a raging hurricane. Giant waves took a toll of 134 officers, men, and their families quartered in the deck cabins, wrecked the deck, and swept the lifeboats into the sea. On December 28 the bark Kilby was able to rescue one hundred passengers. Two days later the San Francisco was sighted by the ship Three Bells but the latter was forced to stand by helplessly until January 3, when she was joined by the Antarctic. Together these ships managed to save about 375 persons. It is estimated that 250 passengers drowned and 59 died of fever.

James E. Butterworth's painting of the final hours of the heroic rescue by the two sailing ships was the source for this 1854 lithograph by N. Currier. The ill-fated *San Francisco* is shown in the center with *Antarctic* on the left and *Three Bells* on the right. This print is considered the most important "disaster" subject ever issued by the firm.

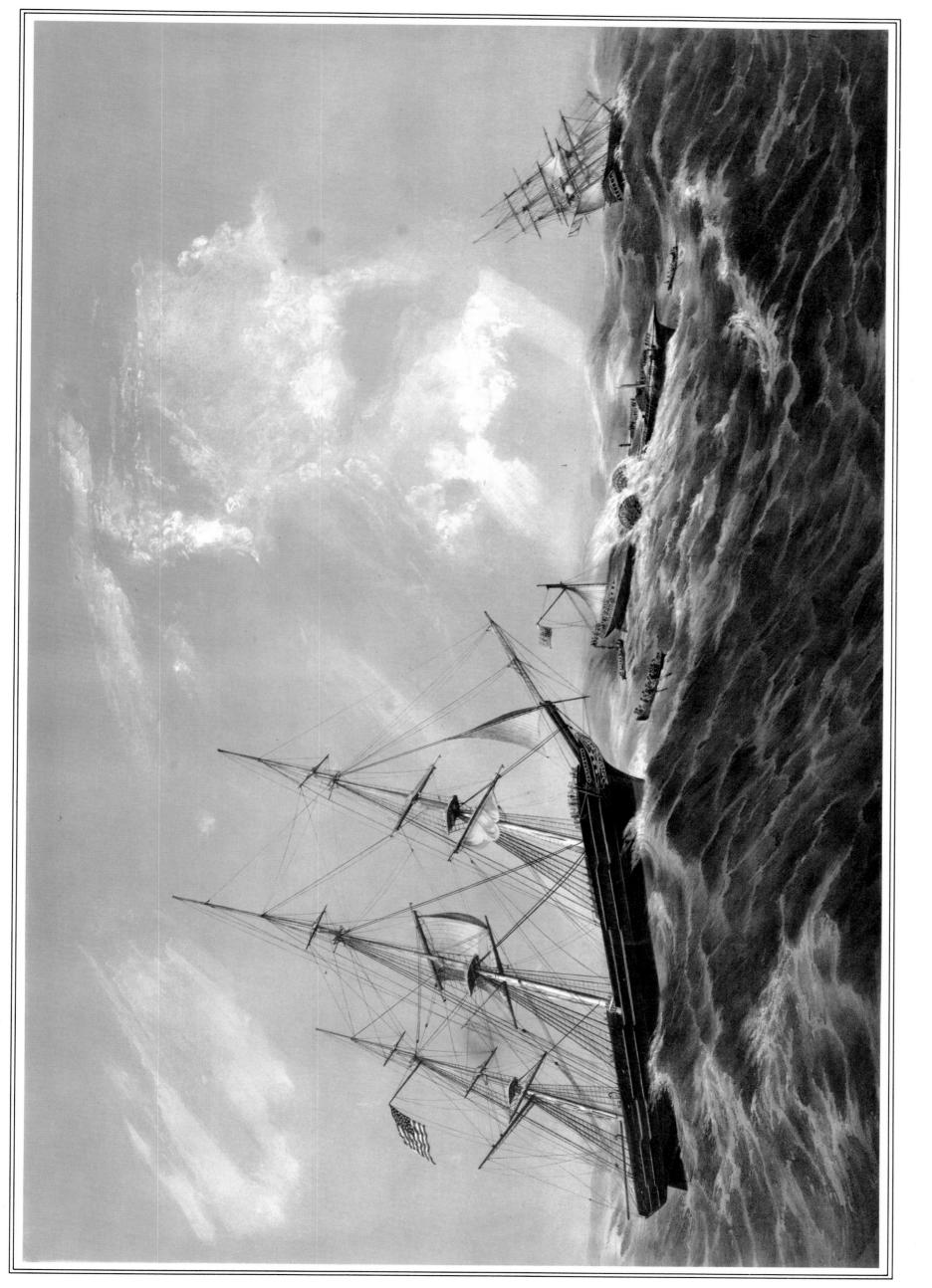

The wreck of the steam ship #SAN Francisco"

STEAM-BOAT KNICKERBOCKER

WHEN ROBERT FULTON'S *Clermont* made the historic first trip by steam from New York to Albany in 1809, it took 32 hours to cover the 150 miles. In the next thirty years, faster and larger boats cut the running time to nine hours. Not only was the schedule to Albany faster and more convenient, but the boats themselves became more luxurious to the point where they were often spoken of as "floating palaces."

The Knickerbocker was a typical steamboat of the period. She was built by the renowned Smith & Dimon yards on the East River in 1843 for owners Daniel Drew and Isaac Newton for use as a Hudson River night boat on the People's Line. At that time the People's Line operated express night trips direct to Albany and also day lines with several landings along the way. The Knickerbocker had a checkered career on the Hudson River, Long Island Sound, and in the Chesapeake Bay region. It was in this latter area, while operating as a government transport, that she was destroyed by Confederate troops in February 1865.

This view of the *Knickerbocker*, showing the hills of Albany in the background, was issued about 1845 by N. Currier, a couple of years after the boat was launched. Currier & Ives published a large series of prints of riverboats of which this is usually judged the most pleasing.

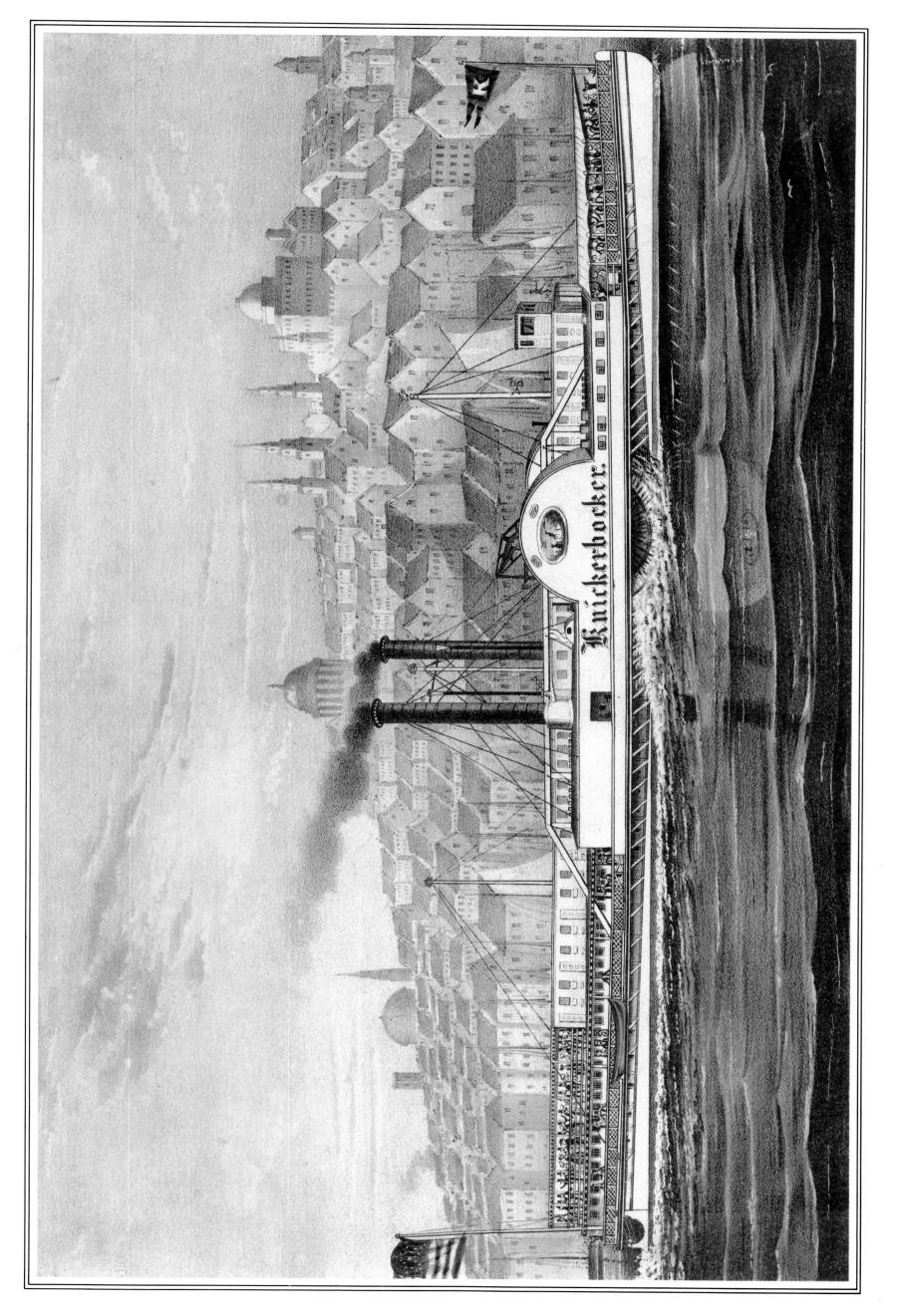

STEAM-BOAT KNICKERBOCKER

A MIDNIGHT RACE ON THE MISSISSIPPI

THE MISSISSIPPI RIVER was the broad highway from the time of the earliest explorers of the continent who came up from the Gulf and down from the Great Lakes. With the coming of the river steamboats, the Mississippi became the most important trade route into the heartland of North America.

The first of the famous paddle-wheel steamers was introduced in 1811. Between 1820 and 1880, six thousand were built. It was natural that competition by owners and riverboat captains would lead to many spectacular races between these great boats. Mark Twain, in his work Life on the Mississippi (1883), describes such a race: "In the 'flush times' of steamboating, a race between two notoriously fleet steamers was an event of vast importance. The date was set for it, several weeks in advance, and from that time forward the whole Mississippi was in a state of consumating excitement The chosen date being come, and all things in readiness, the two great steamers back into the stream, and lie there jockeying a moment, apparently watching each other, like sentient creatures; flags drooping, the pent steam shrieking through safety-valves, the black smoke rolling and tumbling from the chimneys and darkening all the air." It has been said that joining the words of Mark Twain with the visual images created by Currier & Ives offers a complete picture of this era on America's proudest river.

This dramatic night scene of the race between the Natchez and the Eclipse makes this print the best of the many issued by the firm dealing with the Mississippi. Fanny Palmer did the original work for this 1860 lithograph, which is based on H. D. Mannings's sketch of the Natchez.

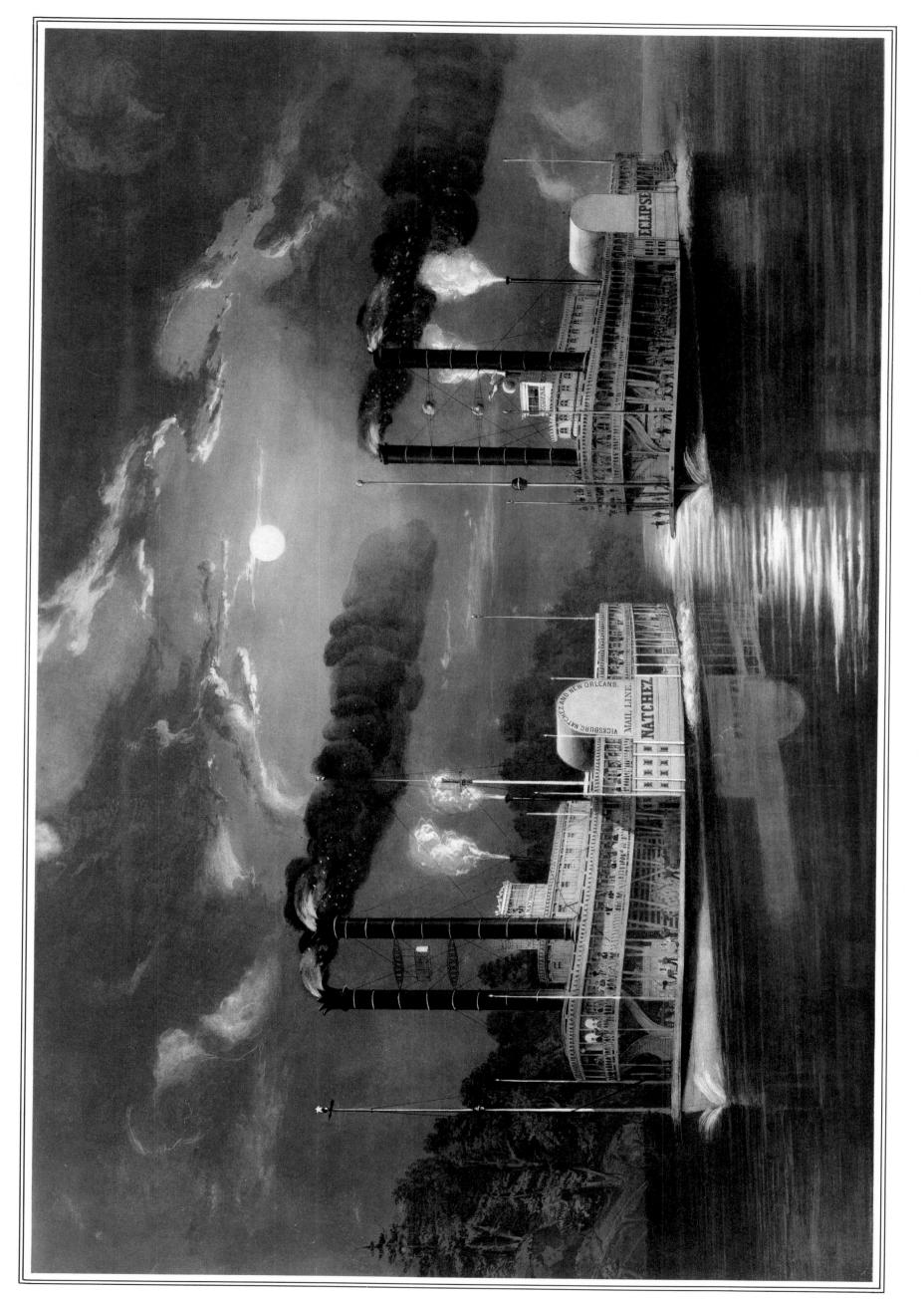

A MIDNIGHT RACE ON THE MISSISSIPPI

THE LIFE OF A HUNTER

"A Tight Fix"

AMONG SERIOUS COLLECTORS, this print is the best known of the estimated seven thousand issued by Currier & Ives. Not only is it a very striking composition, but it is considered the rarest print. In 1929, Harry T. Peters claimed that he had only seen two copies of this lithograph: the one he owned (still part of the Harry T. Peters Collection of the Museum of the City of New York) and a second uncolored copy which belonged to Harry H. Benkard.

Due to its rarity, it has always brought the highest prices on the few occasions a copy has been for sale. In 1928, a record price of \$3,000 was paid at the sale of the Norman James Collection; recently at auction a copy went for \$8,500, the highest sum ever for a nineteenth-century American lithograph. If a print came up for auction today, no one would be surprised at a figure of \$10,000.

As to the scene itself, Louis Maurer reported that he had been in Arthur Fitzwilliam Tait's studio as Tait was working on the original painting. The artist mentioned that the event was witnessed and narrated to him by a guide from Long Lake in the Adirondacks. It seems that the two hunters suddenly came upon a large black bear. The angered animal attacked one, wounding him in the shoulder. Fortunately for the man, the bear hesitated in his attack, giving the second hunter the opportunity to "draw a bead."

60

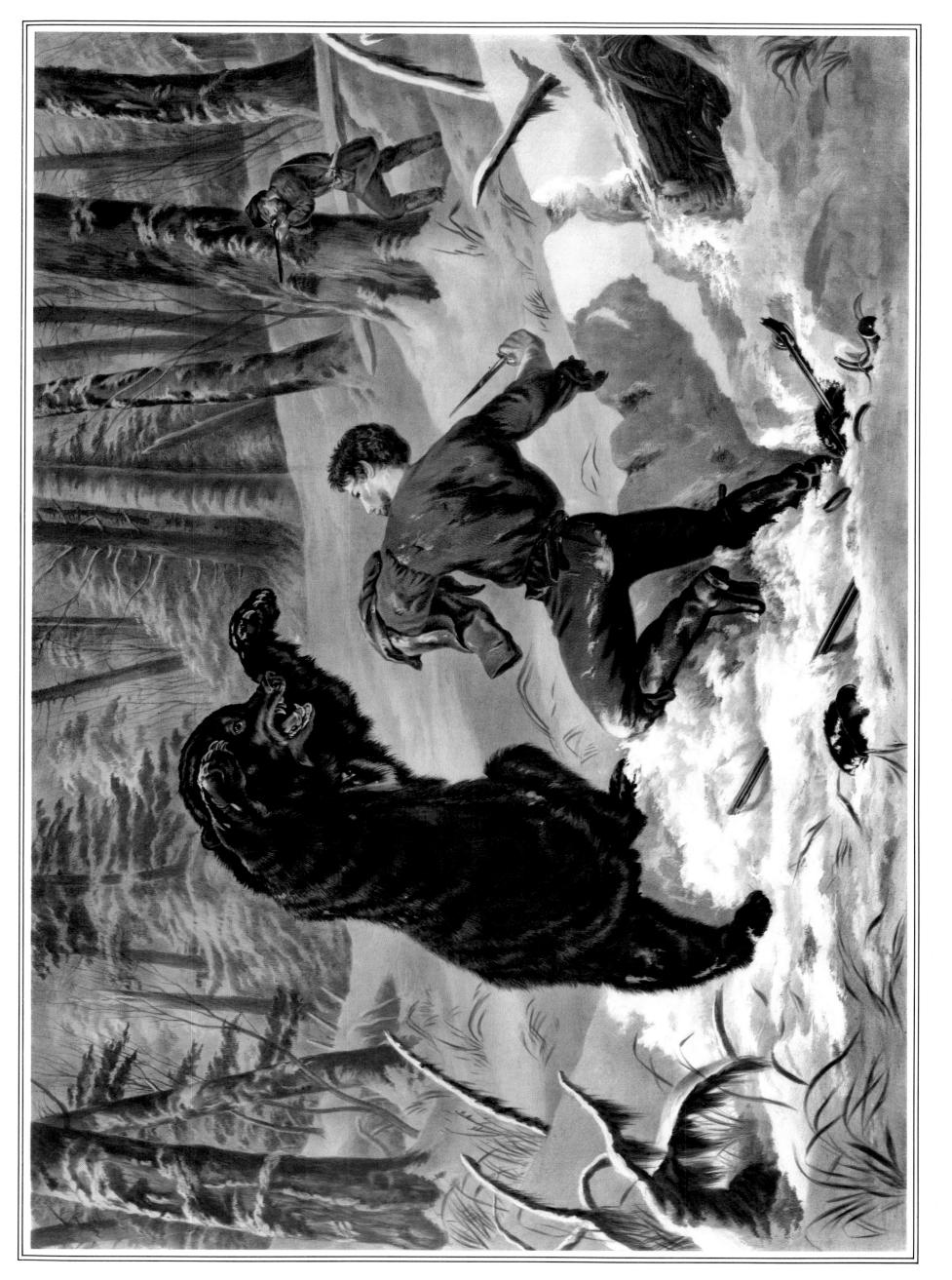

The Life of A HUNTer

MINK TRAPPING

"Prime"

THIS PRINT IS A FINE ADDITION to the series of hunting and fishing scenes of the Adirondacks based on Arthur Tait's work. It is also extremely rare. Tait had a camp in this region and was keenly appreciative of the forest and its wildlife. The accuracy of details and the strength of his overall compositions give his paintings a compelling sense of intimacy and realism.

In this scene it is interesting that a deadfall trap, baited with a fish, is being used rather than the steel trap which was becoming more and more popular during this time. In 1852, ten years before this print was issued, John James Audubon wrote: "The Mink, like the musk-rat and ermine long-tailed weasel, does not possess much cunning, and is easily captured in any kind of trap; it is taken in steel-traps and box-traps, but more generally in what are called dead-falls. It is attracted by any kind of flesh, but we have usually seen the traps baited with the head of a ruffedgrouse, wild duck, chicken, jay, or other bird. The Mink is excessively tenacious of life, and we have found it still alive under a dead-fall, with a pole lying across its body pressed down by a weight of 150 lbs., beneath which it had been struggling for nearly twenty-four hours."

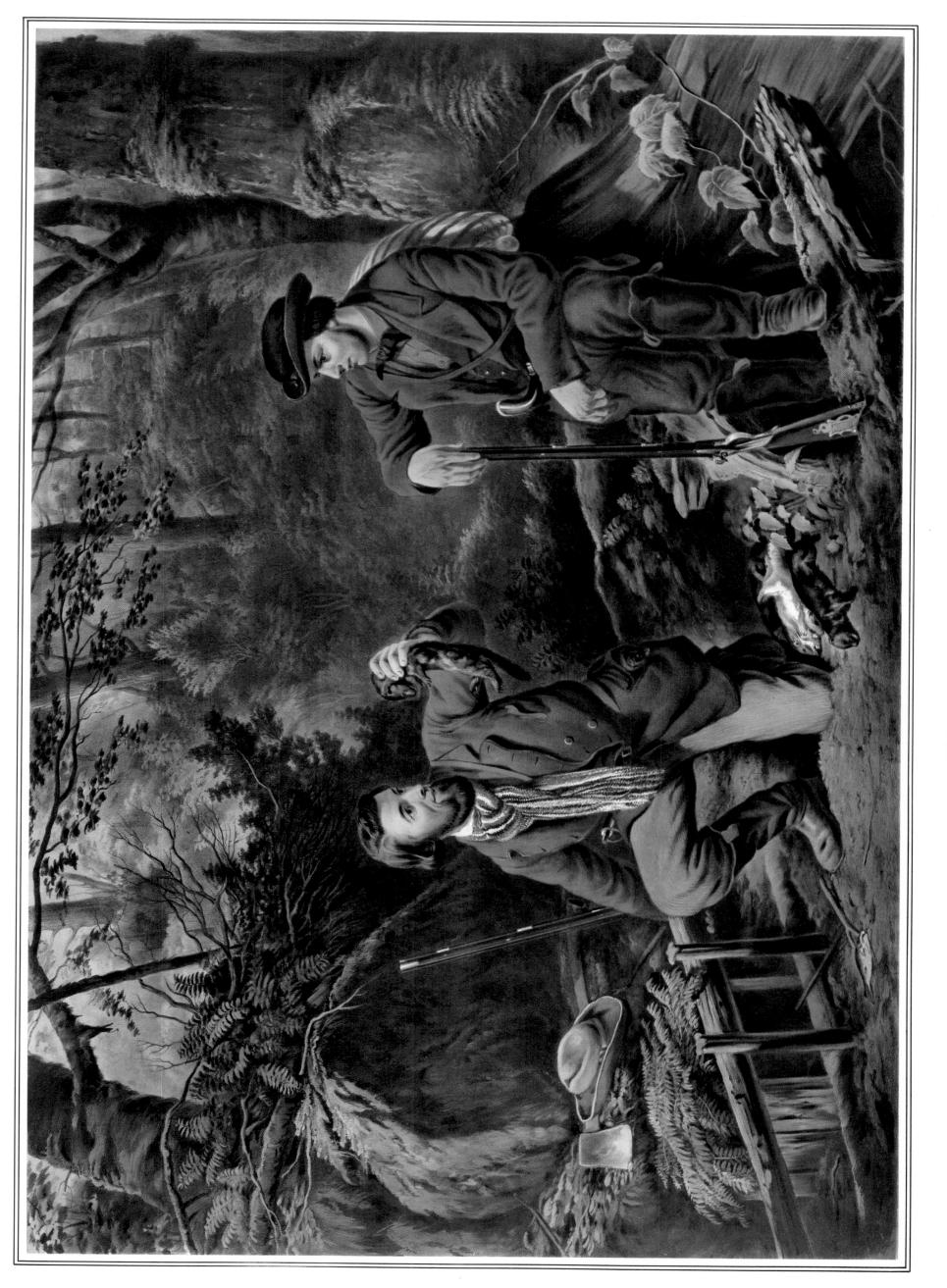

MINE TRAPPING

BEACH SNIPE SHOOTING

BEACH SNIPE SHOOTING has one of the most pleasing compositions of any Currier & Ives print. Until fairly recently the artist for this fine work was unknown, but it has now been verified that the lithograph is based on an 1868 painting by William McEwan, who was working in New York City from 1859 until 1869. Many who are particularly fond of this scene hoped that an attribution could be made to Winslow Homer. Harry T. Peters said of it: "There is nothing else like it. It is so typical of early American shore-bird shooting that for this reason alone, aside from its quality, I think it takes a place in the first rank."

The location for this quiet hunting scene may well be the New Jersey shore, but there are no definite indications. The hunter is poised, waiting for the shore birds to be lured into range by the decoys he has put out at the water's edge. Note the powder horn for his muzzle loader behind his basket.

In 1928, this print "made a record price of \$200" in sale; by 1934 it already was deemed "a genuinely rare print."

BEACH SNIPE SHOOTING

TROLLING FOR BLUE FISH

ONE OF THE LAST AND BEST of the thirty or so fishing scenes done by Currier & Ives between 1840 and 1870, this print has unusual features. Fanny Palmer was the basic artist but Thomas Worth executed the catboat and its crew of four in the foreground. He once said it was his "most satisfying contribution." Worth, who created practically all of the Currier & Ives comics, was perhaps the outstanding cartoonist of his day. In connection with this print, it is interesting that he was also an avid fisherman and boating enthusiast. In all probability the figure at the tiller is Worth's friend Captain Hank Haff, who designed this catboat and later gained fame as skipper of the America's cup defenders *Volunteer, Vigilant, Defender,* and *Independence.* The gentleman just hooking a bluefish may well be a self-portrait of Worth in caricature.

It is fortunate that Mrs. Palmer included twin lighthouses in the background for they set the location for this pleasant afternoon of trolling as just off the Atlantic Highlands of New Jersey. This body of water in the Lower Bay was a favorite area for catching the delicious-tasting Atlantic bluefish.

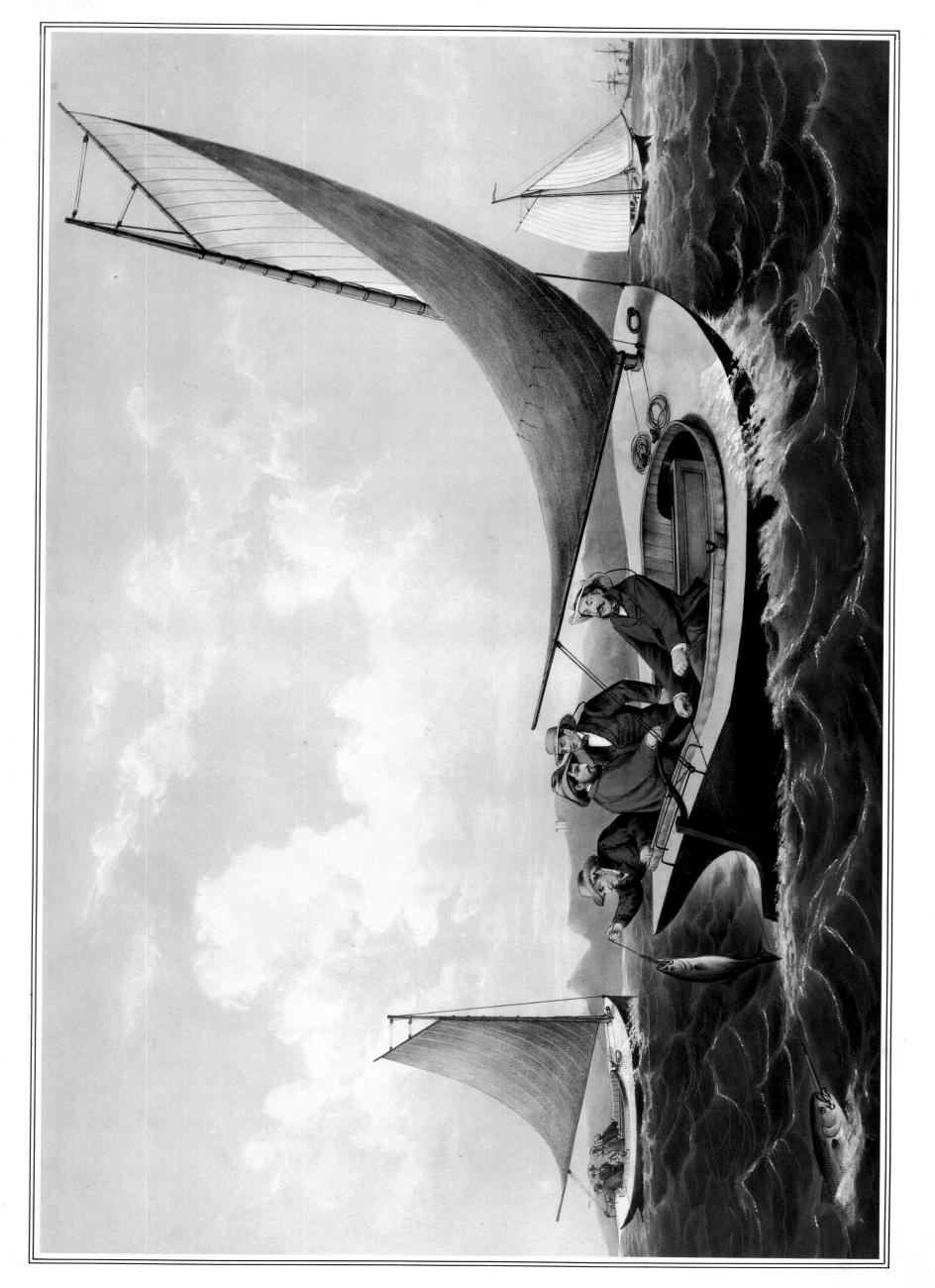

AMERICAN WINTER SPORTS

Trout Fishing "On Chateaugay Lake"

"ON THE FROZEN SURFACE of the lake in front of the picture, stands an enthusiastic disciple of Izaak Walton, who, through a hole cut in the ice, is pulling up a trout to be added to the group of beauties 'of the same sort,' which are lying on the hemlock boughs beside him. In the background is seen the snowcapped hills, and midway the wintry blast whirls the light snow in a cloud before it. This is an extremely pleasing and natural picture, in all its details, and gives a vivid idea of our vigorous northern winters." Thus ran the description of this print in the 1860 catalogue issued by Currier & Ives.

A vivid scene it is, too—one of the most forceful works Arthur Tait furnished the firm. It was put on stone by Charles Parsons in 1856. Tait had a camp on this lake in the Adirondacks in Franklin County, New York, just south of the Canadian border. The fisherman so strikingly portrayed was Thomas Barbour, a personal friend of the artist. Tait himself was an ardent sportsman, spending many hours hunting, fishing, and studying nature and animal life. This further explains the care and accuracy with which the original painting was done.

1

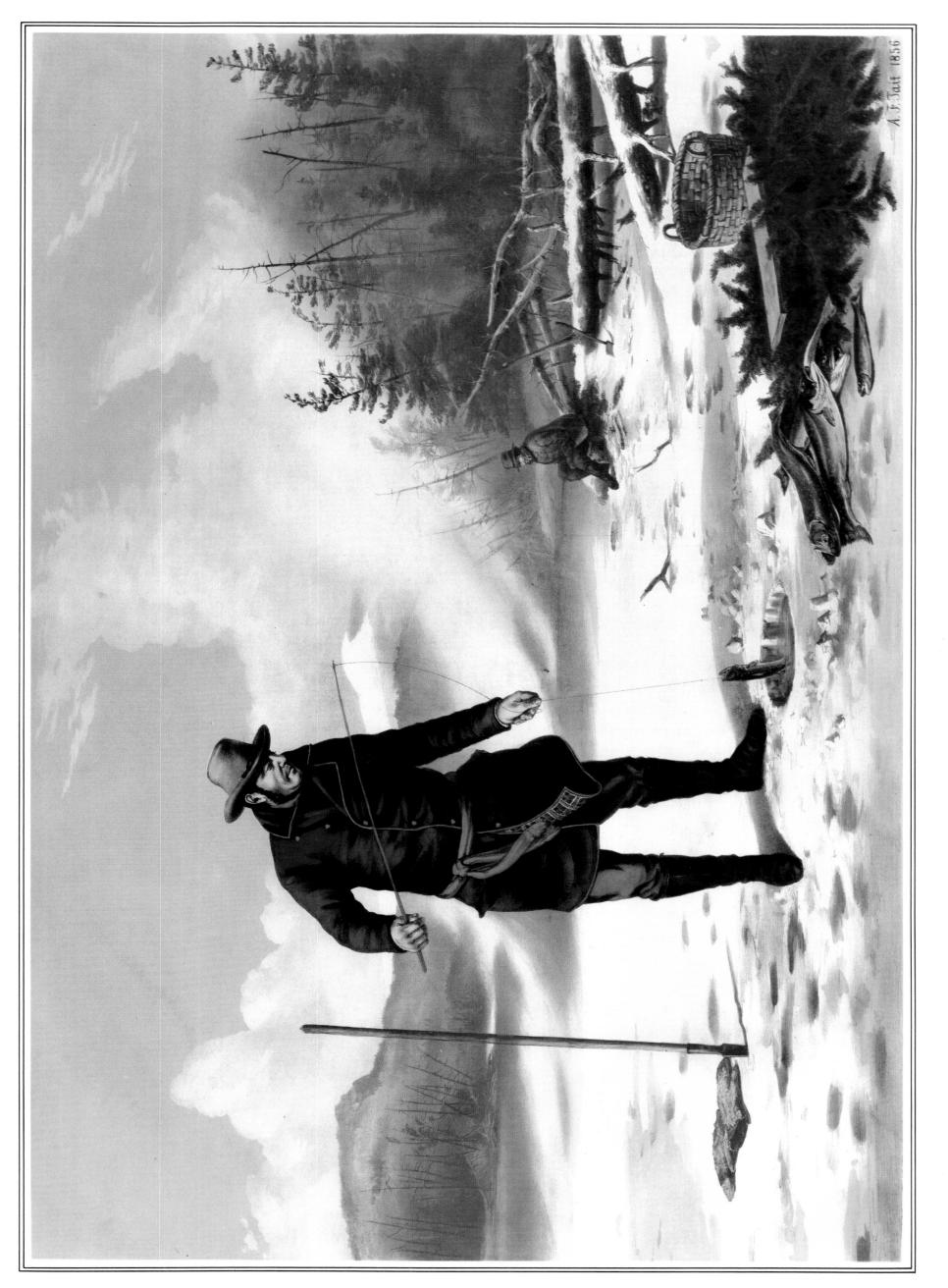

AMERICAN WINTER SPORTS

ICE-BOAT RACE ON THE HUDSON

THE FIRST ICEBOATS were probably sailed by the Dutch during the seventeenth century. Originally sails were mounted on iron runners, somewhat representing a sleigh, but gradually the frame was replaced with light wood construction. During the nineteenth century, iceboating was a very popular sport in America, particularly among the wealthy residents along the Hudson River. Some of the larger boats, equipped with six hundred square feet of sail, could achieve speeds of one hundred miles per hour.

In Hudson Valley Squire, C. Blackburn Miller recounts his first iceboat ride as a boy in the 1890s: "Never before had I experienced such speed. The wind howled in our ears. The shore sped by in a kaleidoscopic panorama of trees, rocks and houses. I felt the excessive cold penetrate my garments and my nose grew numb. I hung on grimly to the cockpit combing with both hands and prayed fervently that our cruise would end safely."

Harry Shaw Newman, editor of a 1934 book on Currier & Ives, commented: "How well Currier & Ives, understood the value of human nature in their print publications! This particular print even today has appeal for four different groups of collectors. It combines the lure of the winter scene, Hudson River view, sporting event and a railroad scene Perhaps the two skippers were enjoying their run along the river against the wood-burning New York Central train as much as their own race."

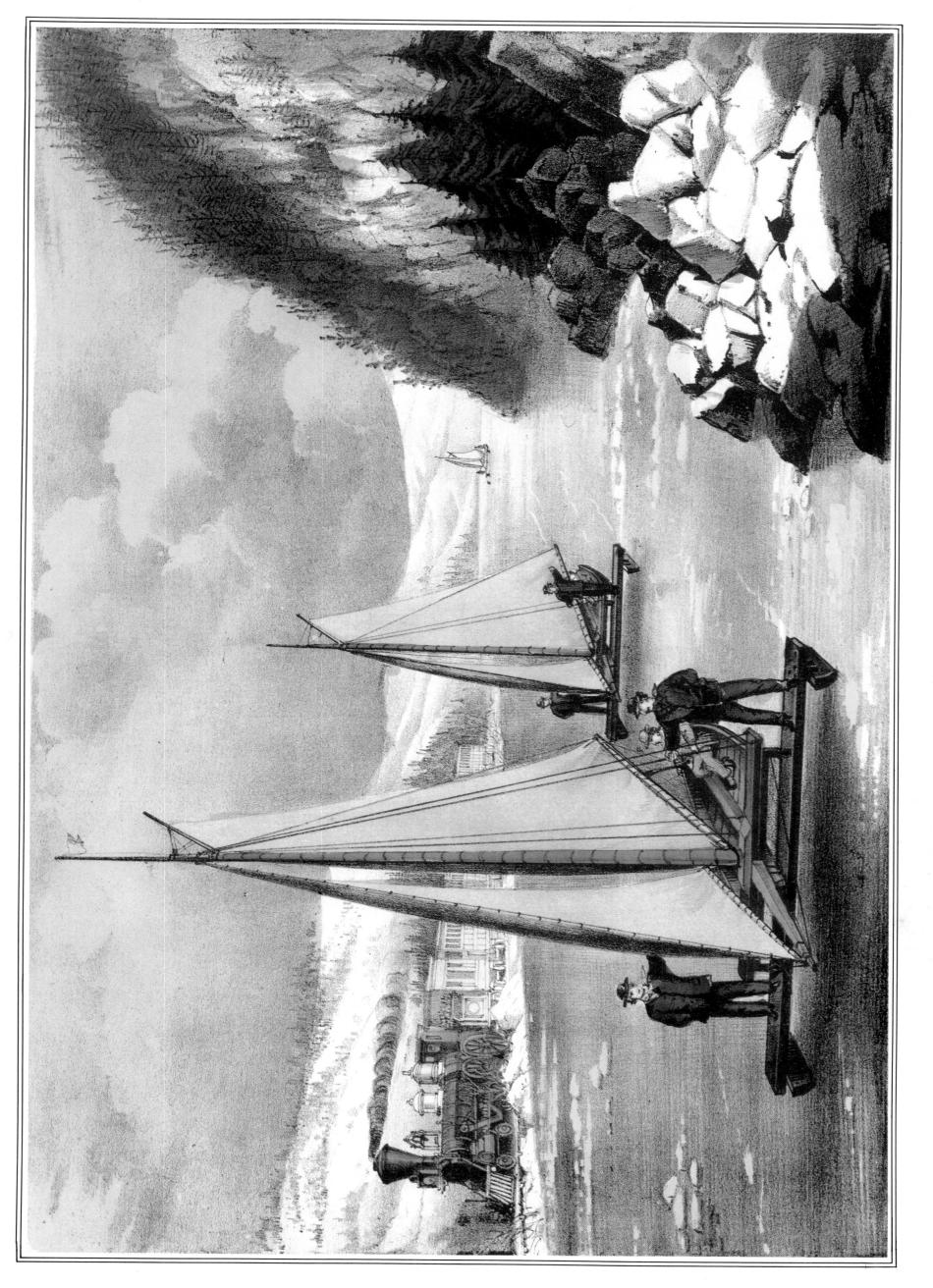

ICE-BOAT RACE ON THE HUDSON

THE CELEBRATED HORSE LEXINGTON

(5 Yrs. Old) By "Boston" out of "Alice Carneal"

LEXINGTON WAS PROBABLY the most famous thoroughbred of the nineteenth century. In his 1905 book *The American Thoroughbred*, Charles Trevathan wrote: "The name of Lexington was handled with scarcely less deference than that of the Diety.... The time is not yet past when the name is synonymous with everything that is greatest in a horse. Lexington belonged not alone to the turfmen. He was the heritage of the nation. He was Lexington in the minds of the people, and after him there were merely other horses."

Son of Boston and Alice Carneal, Lexington not only set track records but also proved most valuable as a stud horse. By 1933 it could be stated that his blood flowed in the veins of most of the racing champions of the day.

Lexington's great race of four miles in 7 minutes $193/_4$ seconds was run over the Metairie Course in New Orleans on April 2, 1855. N. Currier published this print, the finest of the horse prints, in that year. The artist was Louis Maurer, noted for his paintings of animals. When Harry T. Peters was doing research for his great two-volume work *Currier & Ives: Printmakers to the American People*, he talked with Maurer. The artist, reminiscing about his work, reported that he did the sketching of Lexington at Union Course, Long Island. The horse's owner, Richard Ten Broeck, accompanied him and, as darkness fell, left him the carriage so that he could complete the sketch by the vehicle's lantern.

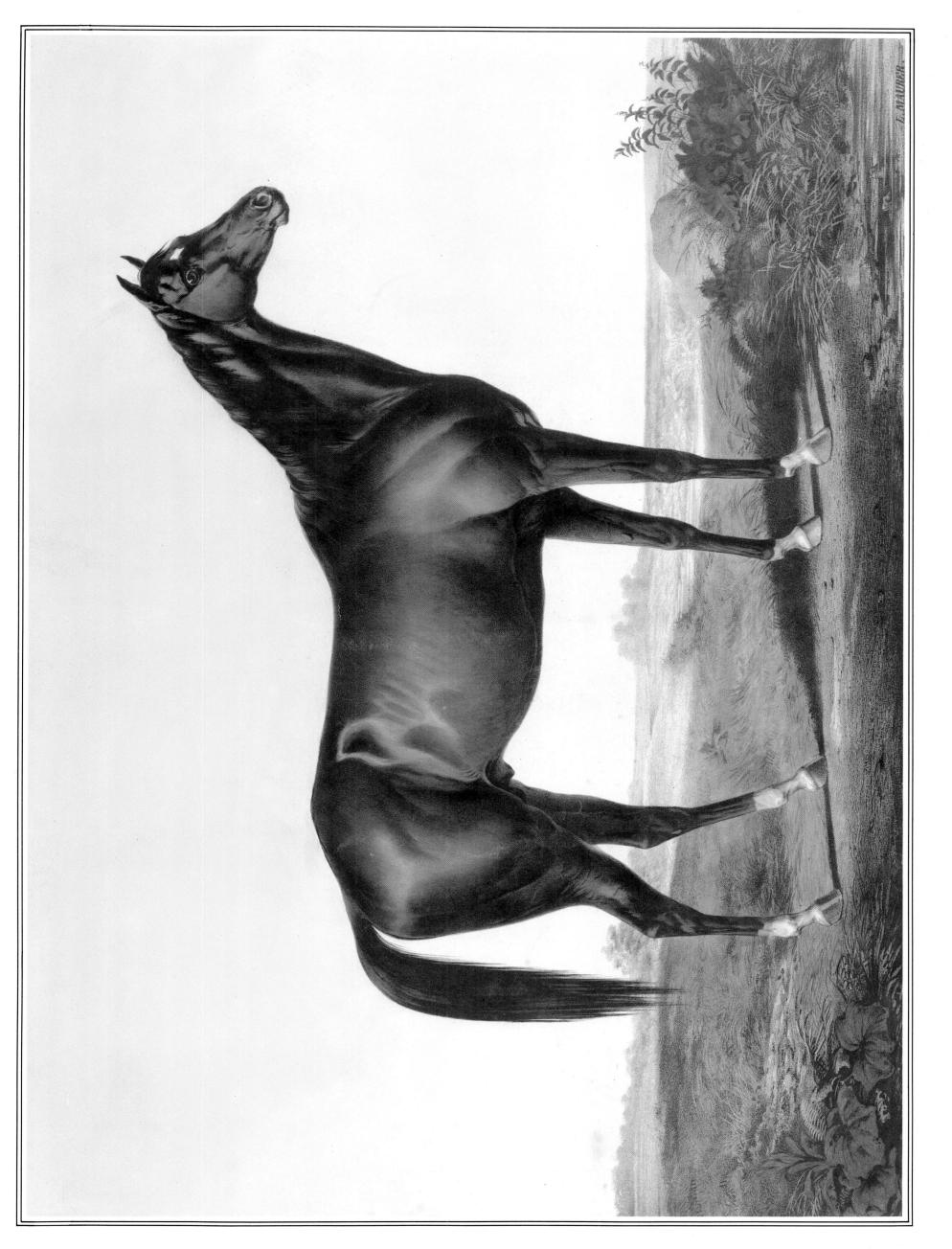

THE CELEBRATED HORSE LEXINGTON

PEYTONA AND FASHION

In Their Great Match for \$20,000

Over the Union Course, L. I.

May 13th, 1845, Won by Peytona Time: 7:393/4 7:451/4

THIS LITHOGRAPH by Charles Severin depicts one of the famous horse races of America, which was run over the Union Course, Long Island, on May 13, 1845. Peytona, owned by Thomas Kirkman of Alabama, won the first two heats in a race of the best out of three four-mile heats. Her opponent was the northern horse Fashion, belonging to Henry K. Toler of New Jersey. The purse of \$20,000 was unusually large for the time, and betting was very high. Peytona's remarkable time was 7 minutes 393/4 seconds and 7 minutes 451/4 seconds.

Mentioning the event in his diary, Philip Hone noted that Wall Street was wholly deserted that day. "The race was won easily by Peytona. The Southern mustaches curled with exultation, and the bachelors of the Union Club talked less wisely and loftily than is their wont."

In the 1860 Currier & Ives catalogue, this scene is described as "one of the best pictures of a race ever published. It shows almost the entire course with the immense crowd of spectators that assembled to witness this contest between the North and South. The horses and riders are faithfully portrayed in the foreground as they appeared in the last mile of the second heat, when making every effort to secure the victory. The center of the ring is filled with vehicles of all descriptions, equestrians and pedestrians."

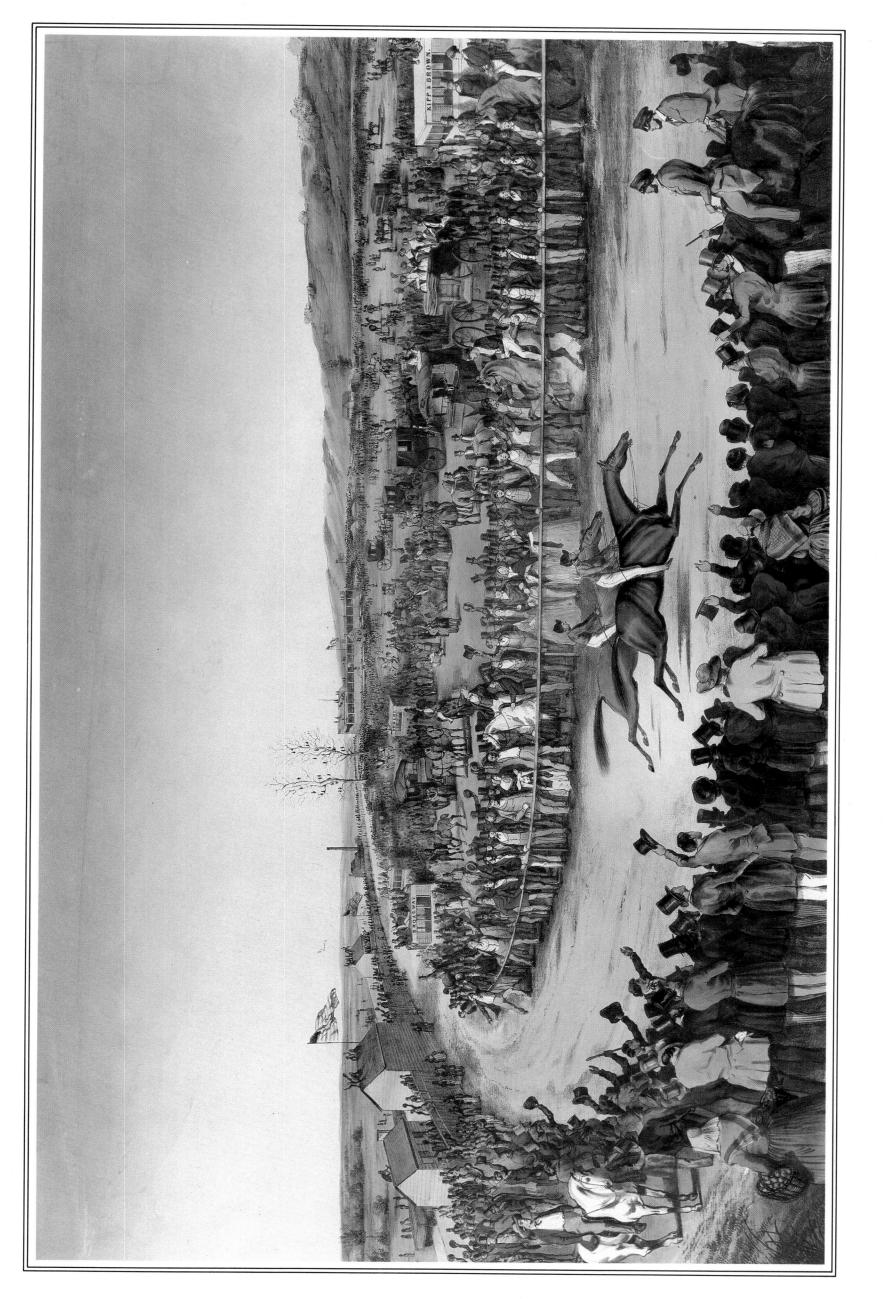

PETTONA AND FASHION

THE AMERICAN NATIONAL GAME OF BASE BALL

Grand match for the championship at the Elysian Fields. Hoboken, N. J.

ALTHOUGH IT IS GENERALLY conceded that the first match game of baseball was held on June 19, 1846, between the Knickerbocker Club and the New York Club at the Elysian Fields, Hoboken, New Jersey, this print, done in 1866, is the earliest and most important one known to exist on the subject of baseball.

The scene, according to extensive research done by the print collector Milton L. Bernstein, depicts the game played on August 3, 1865, between the Atlantics and the Mutuals in which the Atlantics won thirteen to twelve. The well-known sports columnist Red Smith concurs and adds that the batter was Dickey Pearce, star shortstop of the Atlantics, who devised "the technique of tapping the ball gently in front of the plate and racing to first before the defense could recover." It is questionable that this was a "championship" match, but as Mr. Bernstein says, "during the early days of baseball, however, a championship could, and often did, change with every game played."

It is curious that Currier & Ives did only one print relating to baseball. However, they were prophetic in their choice of title as baseball certainly became the national game, and as a consequence this print has become a collector's item.

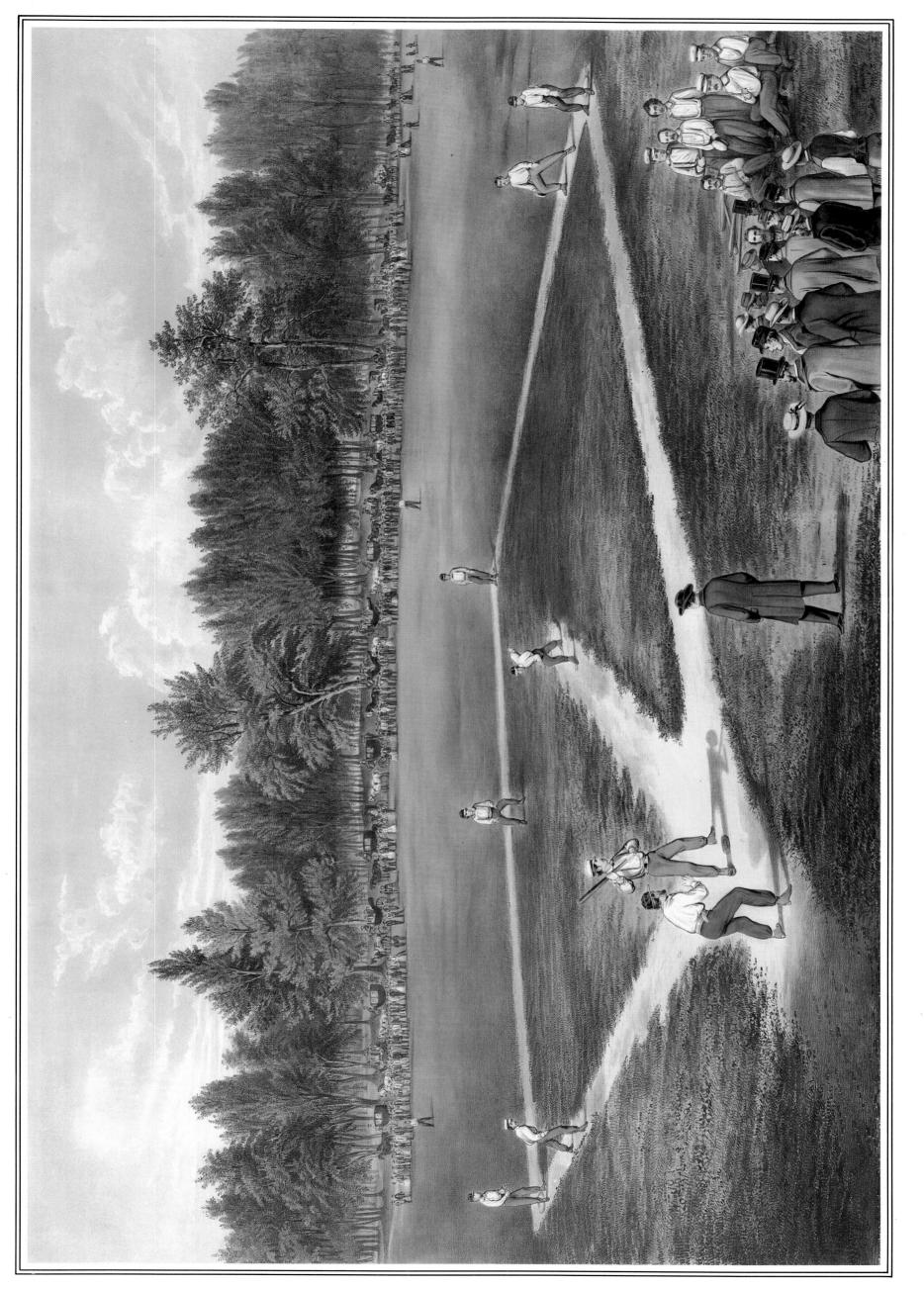

THE AMERICAN NATIONAL GAME OF BASE BALL

THE DESTRUCTION OF TEA AT BOSTON HARBOR

IN THE YEARS OF MOUNTING TENSIONS between Britain and the American colonies, the duty on tea imposed by Parliament and the attempts made by the East India Company to dump their surplus stock of tea on the colonial market tried American patience to the breaking point. Resolutions were passed, broadsides were circulated, and associations, such as the Sons of Liberty of New York, were formed to give voice to resentment of the tea tax.

On November 27, 1773, the Dartmouth, the first of three tea ships, arrived at Boston. After two mass meetings, the colonists resolved that the tea must be sent back to England. Governor Thomas Hutchinson refused. A twenty-day waiting period was to ensue under customs regulations. However, on December 16, a group organized by Samuel Adams and vaguely disguised as Mohawk Indians rushed to Griffin's Wharf, boarded the three ships, and worked through the night dumping the tea into the harbor. There were 342 chests valued at £18,000.

This was a climactic event. One Englishman stated flatly that it was "the most wanton and unprovoked insult offered to the civil power that is recorded in history." From this moment on, relations between the colonies and the mother country were on a continuing downhill slide.

In spite of inaccuracies—particularly the fact that the "tea party" took place under cover of darkness—this 1846 N. Currier lithograph is one of the most dramatic renditions of the historic event.

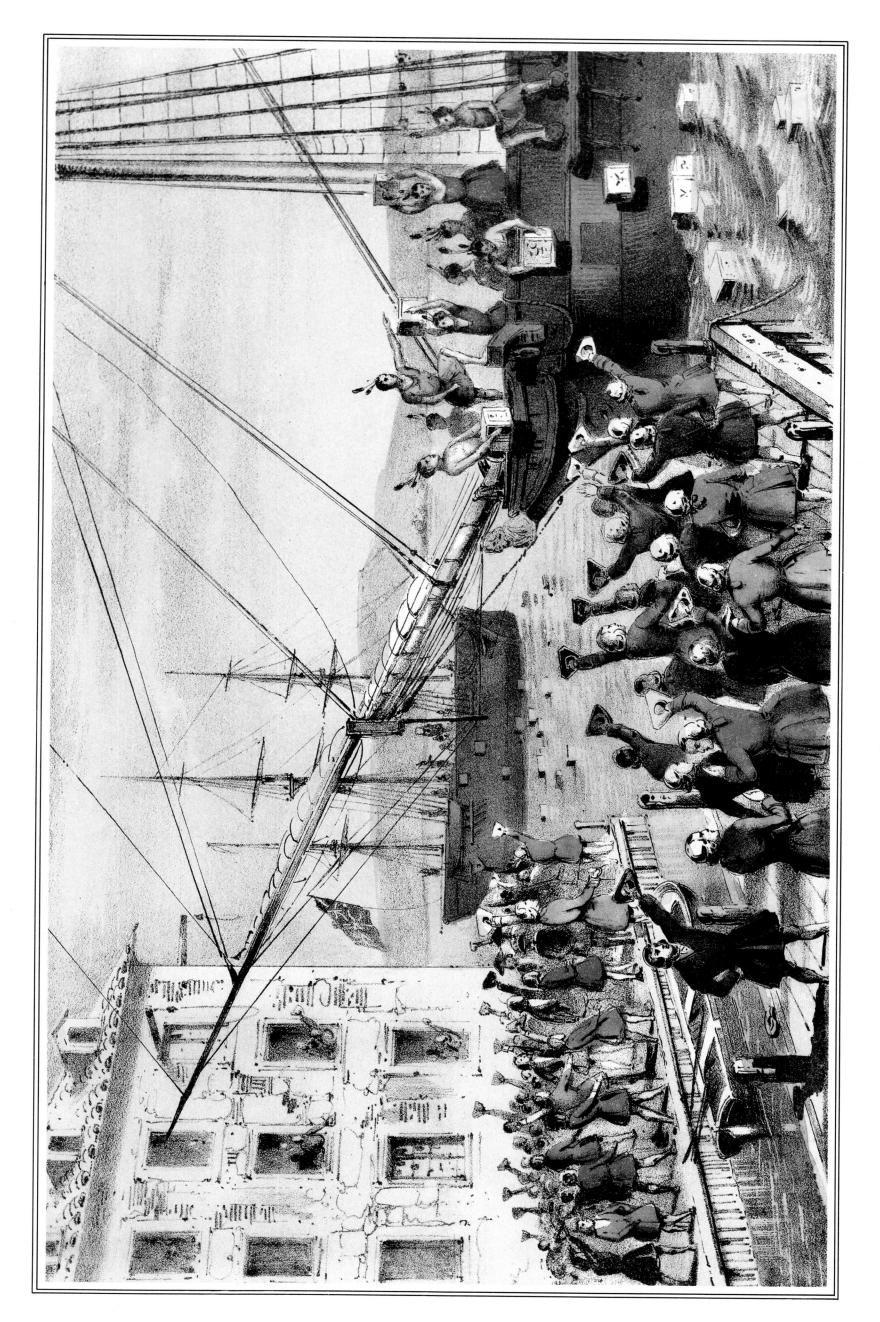

THE DESTRUCTION OF TEA AT BOSTON HARBOR

BATTLE AT BUNKER'S HILL

June 17th 1775

THE FORTIFYING OF BREED'S HILL, north of Charlestown, Massachusetts, on the night of June 16, 1775, precipitated, the next day, the military engagement commonly called the Battle of Bunker Hill, a neighboring fortification. This was the first real standup fight between untried colonial troops and British regulars; although the redcoats won the hill, they lost 1,054 killed and wounded out of 2,200 engaged, against American losses of 441 out of an estimated 3,200 engaged. "A dear bought victory," wrote General Clinton, "another such would have ruined us." And General Gage wrote home to England plaintively: "Those people shew a spirit and conduct against us, they never shewed against the French."

Although John Trumbull witnessed the battle from across Boston Harbor, he did not complete his painting entitled *The Death of General Warren at the Battle of Bunker's Hill, 17 June, 1775* until 1786 in Benjamin West's London studio. (Dr. Joseph Warren, newly commissioned major general, was in command of the Massachusetts militia.) An engraving of this painting was first published in London in 1788 and then widely copied. One of these engravings was unquestionably the basis for this lithograph by N. Currier, which is accurate as to general detail but pales when compared to Trumbull's original work or his later **replicas**.

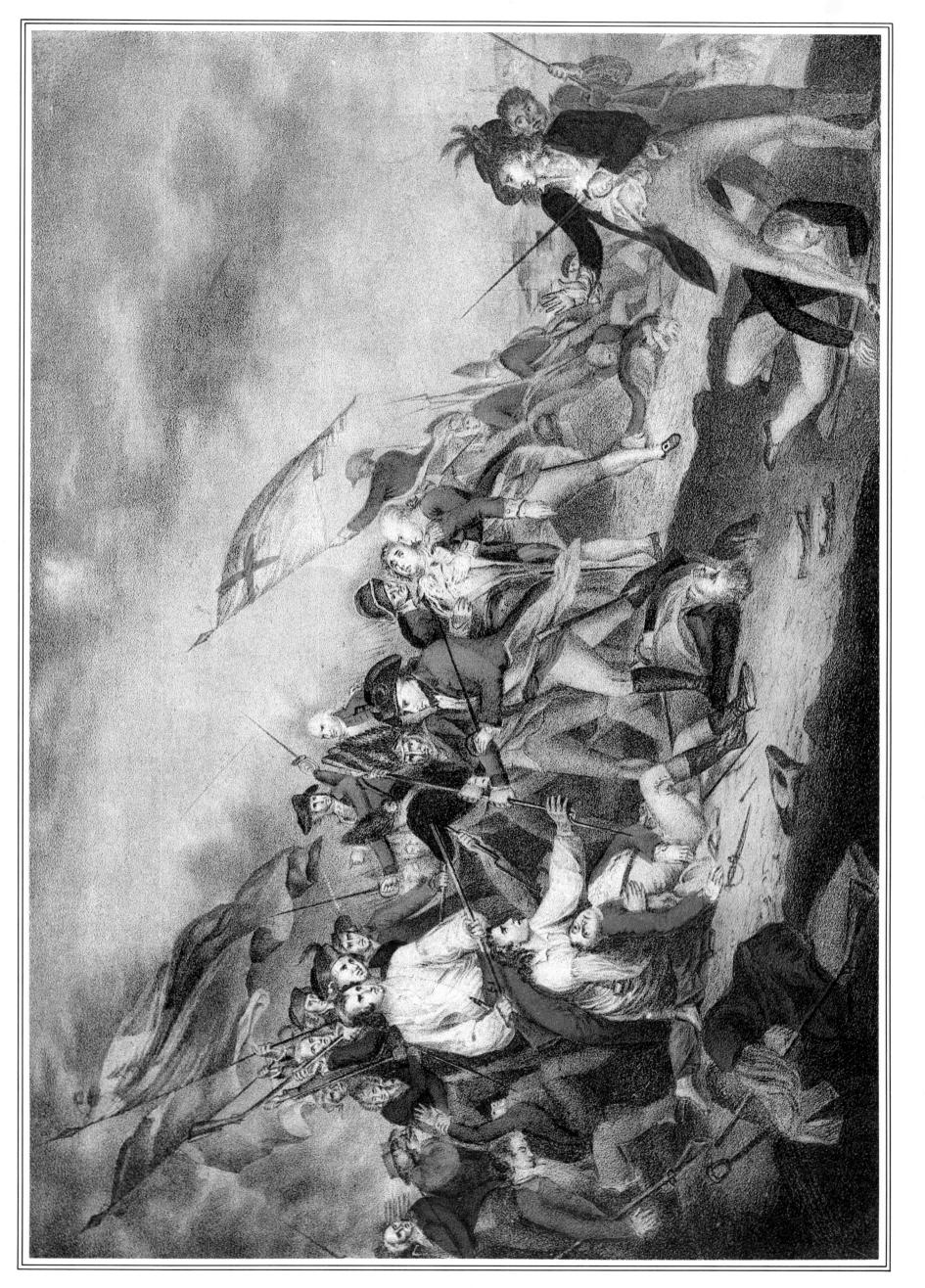

BATTLE AT BUNKER'S HILL

WASHINGTON TAKING LEAVE OF THE OFFICERS OF HIS ARMY At Francis's Tavern, Broad Street, New York, Dec. 4th 1783

ONE OF THE MOST POIGNANT MOMENTS in the early history of our country occurred on the afternoon of December 4, 1783, when General George Washington bade farewell to his officers at Fraunces Tavern in New York City. In a very short address. perhaps Washington's most eloquent, he said: "With a heart full of love and gratitude, I now take leave of you; I most devotedly wish, that your latter days may be as prosperous and happy as your former ones have been gracious and honorable." *Rivington's New York Gazetteer*, reporting on the event, commented on the speech: "The words produced extreme sensibility on both sides, they were answered by warm expressions and fervent wishes, from the Gentlemen of the Army, whose truly patriotic feeling, it is not in our power to convey to the reader."

N. Currier depicted this scene in an 1848 lithograph. Quite naturally he showed Washington toasting his fellow officers. It is a significant reflection on the changing mores of the third quarter of the nineteenth century that when the firm reissued this print in 1876 the wine glass was removed from Washington's hand and a tricorn hat replaced the decanter! The Temperance Movement had become so strong by this date that it was felt improper to show the "Father of Our Country" associated with liquor even in an historical setting.

The 1848 print also misspelled Fraunces' name; in the 1876 issue the subtitle merely read "At the old Tavern, corner of Broad and Pearl Sts."

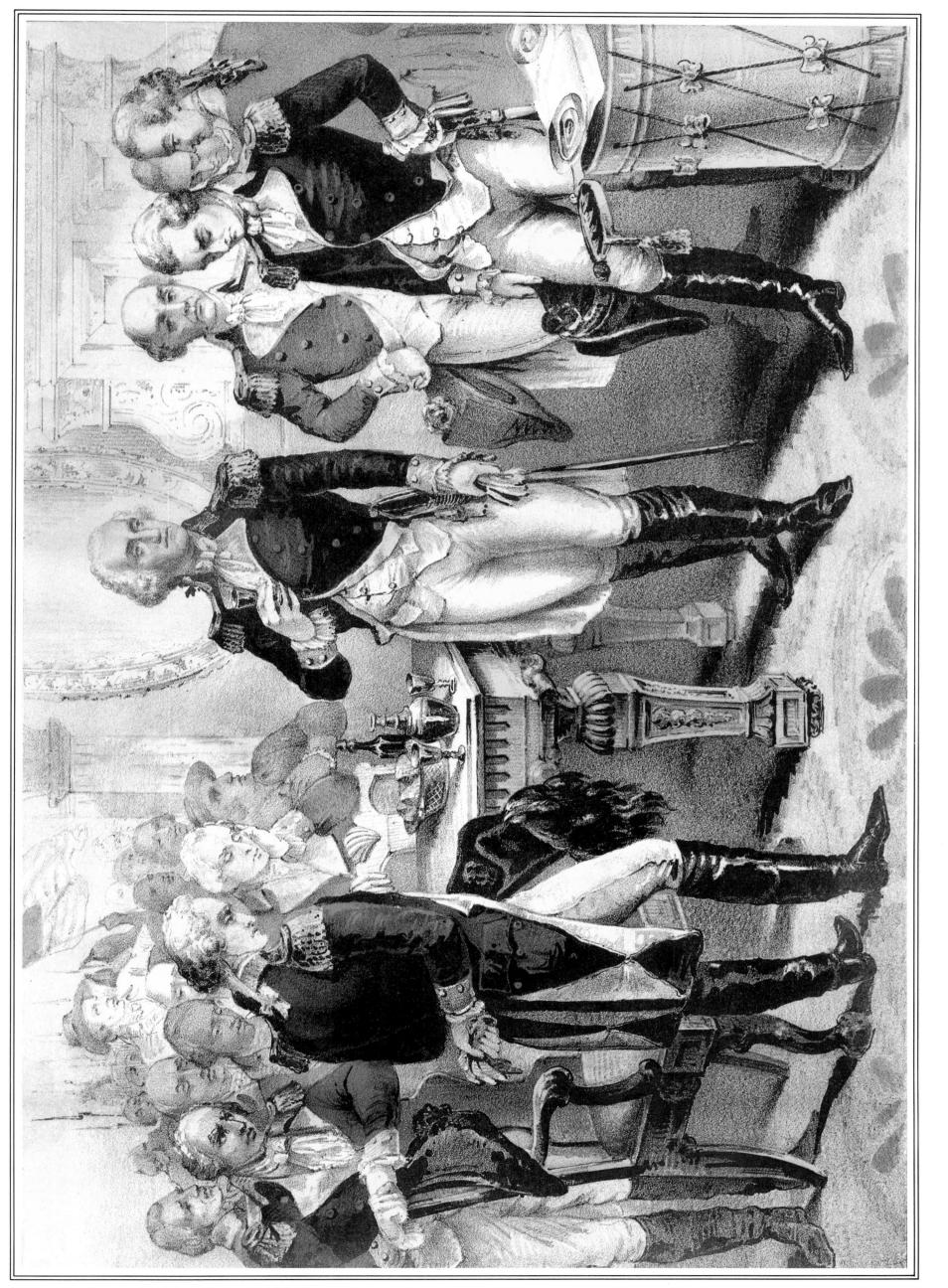

WASHINGTON TAKING LEAVE OF THE OFFICERS OF HIS ARMY

PERRY'S VICTORY ON LAKE ERIE Fought Sept. 10th 1813

This plate represents the position of the two Fleets at the moment when the NIAGARA is pushing through the enemy's line, pouring her thunder upon them from both broadsides, and forcing them to surrender in succession to the American Flag COMMODORE PERRY, having a short time before left the LAWRENCE in a small boat, amidst a tremendous fire from the British Squadron and hoisted his Flag on board the NIAGARA

"We have met the enemy and they are ours." COM: O. H. PERRY

EVEN THOUGH THIS PRINT has been called "one of the finest of the large group of naval subjects," it is perhaps fortunate that N. Currier decided to give an extended description with the title. From the print alone one might wonder what precise action is being depicted. This naval engagement began at quarter to twelve on September 10, 1813, and ended at precisely three o'clock that afternoon.

Oliver Hazard Perry, America's greatest naval hero of the War of 1812, was appointed a midshipman in the Navy in 1799 at the age of fourteen. By 1812 he had risen to the rank of commander. During the spring and summer of 1813 he was given the difficult task of building, equipping, and manning a fleet of ten small vessels at Erie, Pennsylvania. This was particularly arduous since a large part of the supplies had to be procured on the coast and transported through the wilderness.

With the Lawrence selected as the flagship (the flag bore the dying words of Captain James Lawrence, "Don't give up the ship"), the staunch little fleet was ready to engage the British on Lake Erie. Upon his victory, Commodore Perry issued his now famous report to General W. H. Harrison: "We have met the enemy and they are ours." The victory secured control of Lake Erie and helped in the later invasion of Upper Canada.

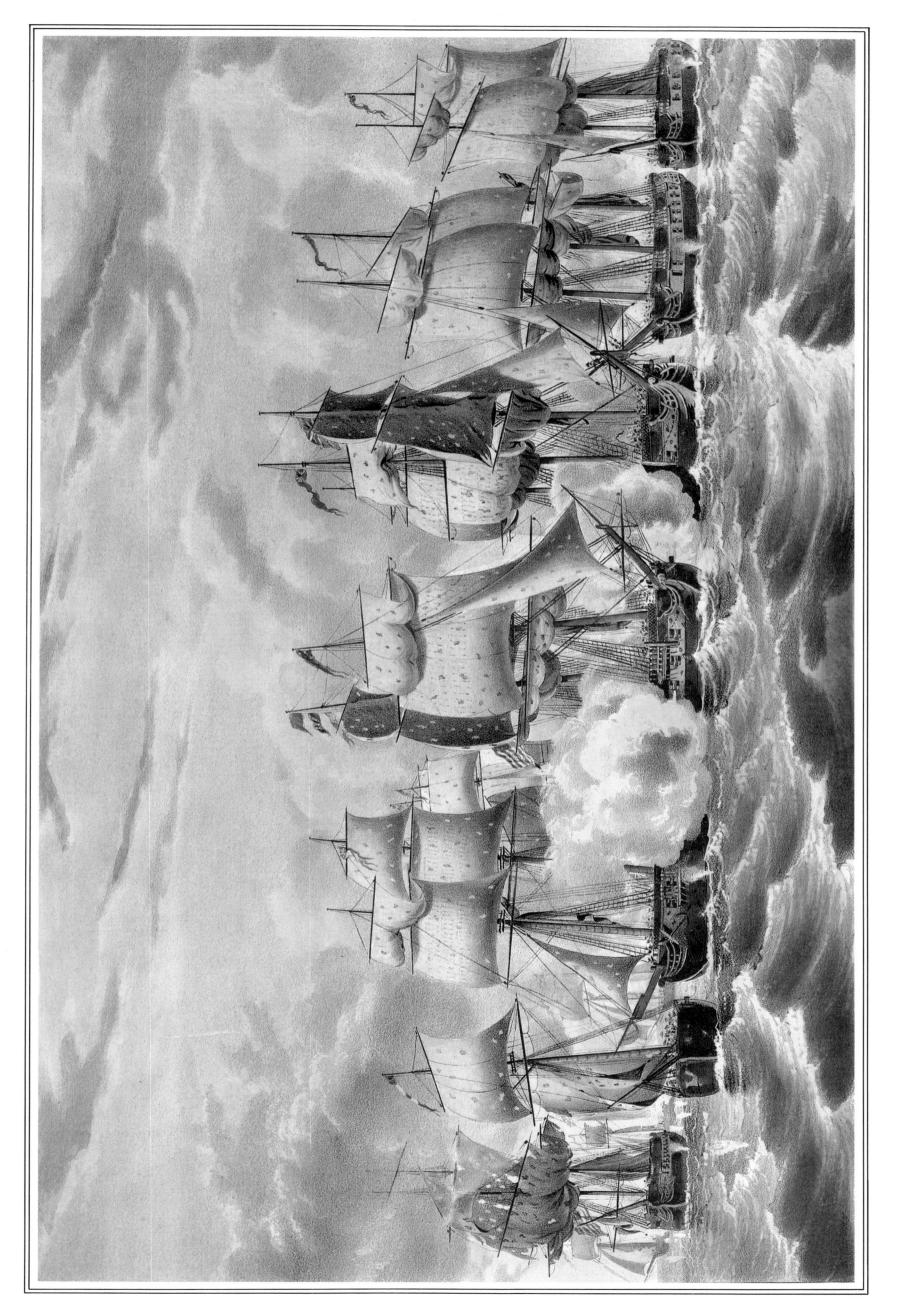

-

PERRY'S VICTORY ON LAKE ERIE

HON. ABRAHAM LINCOLN

Republican Candidate for Sixteenth

President of the United States

WHILE ABRAHAM LINCOLN was in New York giving a political address at Cooper Union on February 27, 1860, he had his photograph taken by Mathew Brady. It is believed that the circulation of this photograph (the so-called beardless Lincoln) and the praises for his speech advocating the abolition of slavery in the territories were the principal factors in his winning the Republican nomination for the presidency. Currier & Ives, politically aligned with the Republican party, used the Brady photograph as the basis for this fine lithographic portrait.

The firm executed about four hundred portraits of noted persons with thirty-five alone relating to Lincoln—second only to the number devoted to George Washington. According to Harry T. Peters: "Lincoln was made to order for the house of Currier, which made the most of him. They made him caricature and cartoon, in full face and profile, in half-length and full figure, seated and standing. They showed him with 'Tad,' pictured him in the bosom of the family, portrayed him being assassinated, and made public his deathbed." Of these portraits this now scarce study is unquestionably the finest the firm did, probably the most important one they ever produced.

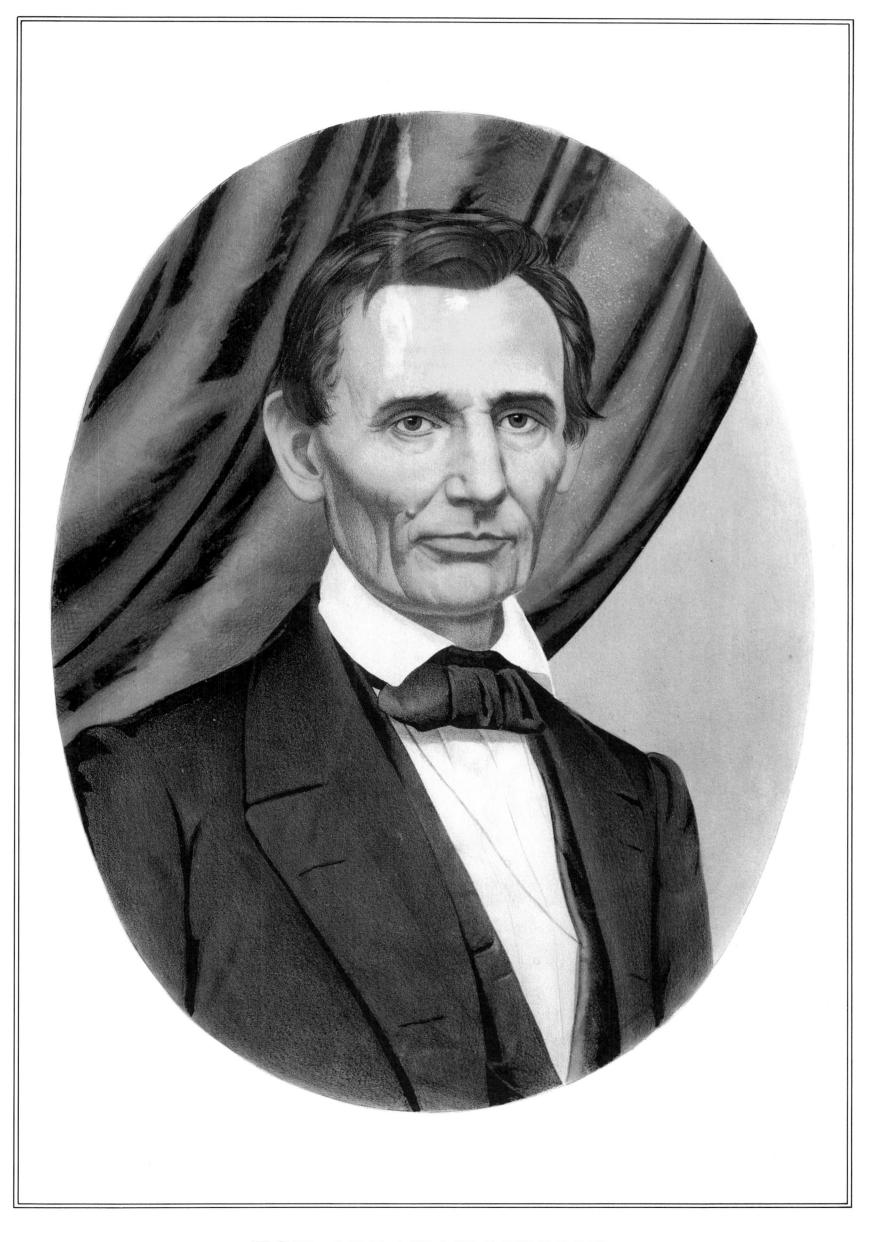

Hon. Abraham Lincoln

THE SPLENDID NAVAL TRIUMPH ON THE MISSISSIPPI April 24th 1862

THE MOST IMPORTANT BLOW to the Confederacy by the end of the first year of fighting was the capture of New Orleans. This was made possible by the naval victory at the mouth of the Mississippi. David Glasgow Farragut, an elderly but still spry officer, commanded the strong fleet of fighting craft and mortar vessels. For a week in mid-April the mortar boats accurately tossed shells into Forts Jackson and St. Philip, which guarded the approach to New Orleans. Then, in the early-morning darkness of April 24, Farragut's ships ran past the forts and steamed up the river, engaged the outnumbered Confederate vessels, and were easily victorious.

In spite of a certain Fourth of July quality, Currier & Ives' depiction of this engagement is probably the most dramatic of the nearly one hundred prints of the Civil War made by the firm. With their sales cut off from the South and their natural leaning toward the Union cause, it is not surprising that—regardless of the outcome of the battles—the northern forces nearly always appeared victorious. The Union soldiers are portrayed in perfect order whereas their enemy's lines are broken and in complete disarray.

In the first Battle of Bull Run, described in part by the noted historian Samuel Eliot Morison, "the Union lines began to retreat, and the retreat became a rout. All next day soldiers were straggling into Washington without order or formation, dropping down to sleep in the streets." Currier & Ives, on the other hand, in their subtitle for this battle print, declared: "Gallant Charge of the Zouaves and Defeat of the Rebel Black Horse Cavalry." There is no mention of the final reckoning. It is only fair to mention, however, that the firm was wholly dependent on newspaper accounts, which were far from accurate.

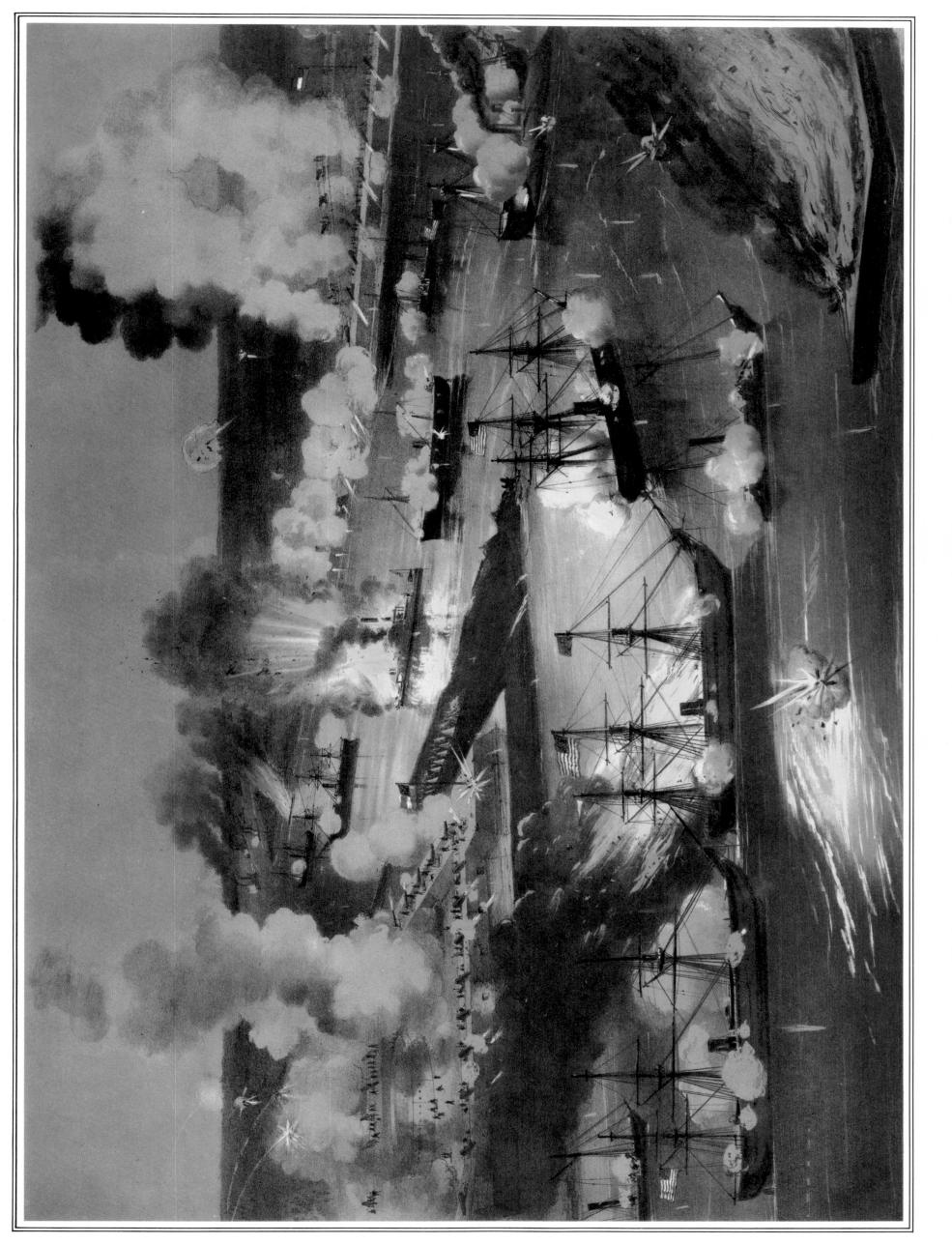

THE SPLENDID NAVAL TRIUMPH ON THE MISSISSIPPI APRIL 24 TH, 1862

THE VILLAGE BLACKSMITH

Under a spreading chestnut tree, The village smithy stands; The smith, a mighty man is he, With large and sinewy hands; And the muscles of his brawny arms Are strong as iron bands. And children coming home from school Look in at the open door; They love to see the flaming forge, And hear the bellows roar, And catch the burning sparks that fly Like chaff from a thrashing floor.

LONGFELLOW

THE FIRST TWO LINES of the eight-stanza poem *The Village Black-smith* by Henry Wadsworth Longfellow are among the best known in all American poetry, but probably few of us remember the poem in its entirety. The idea for *The Village Blacksmith* was suggested to Longfellow by his seeing a smithy working under a tree near his home in Cambridge, Massachusetts. In the final stanza, the poet makes him a symbol of the proper conduct of life. The poem was first published in the November, 1840 issue of *Knickerbocker Magazine* when Longfellow was thirty-three. He was paid the grand sum of fifteen dollars! By 1874 he was America's favorite poet, referred to as *the Victorian poet*, and was paid \$3,000 for *The Hanging of the Crane*.

Longfellow's sentimentality made his work ideally suited to the presses of Currier & Ives. A typical example occurs in *The Village Blacksmith* where the smithy hears his daughter singing in the nearby church and is reminded of "her mother's voice singing in Paradise!" Currier & Ives did three different versions of *The Village Blacksmith*, five of *Hiawatha*, and one each of *Evangeline* and *Tales of a Wayside Inn*.

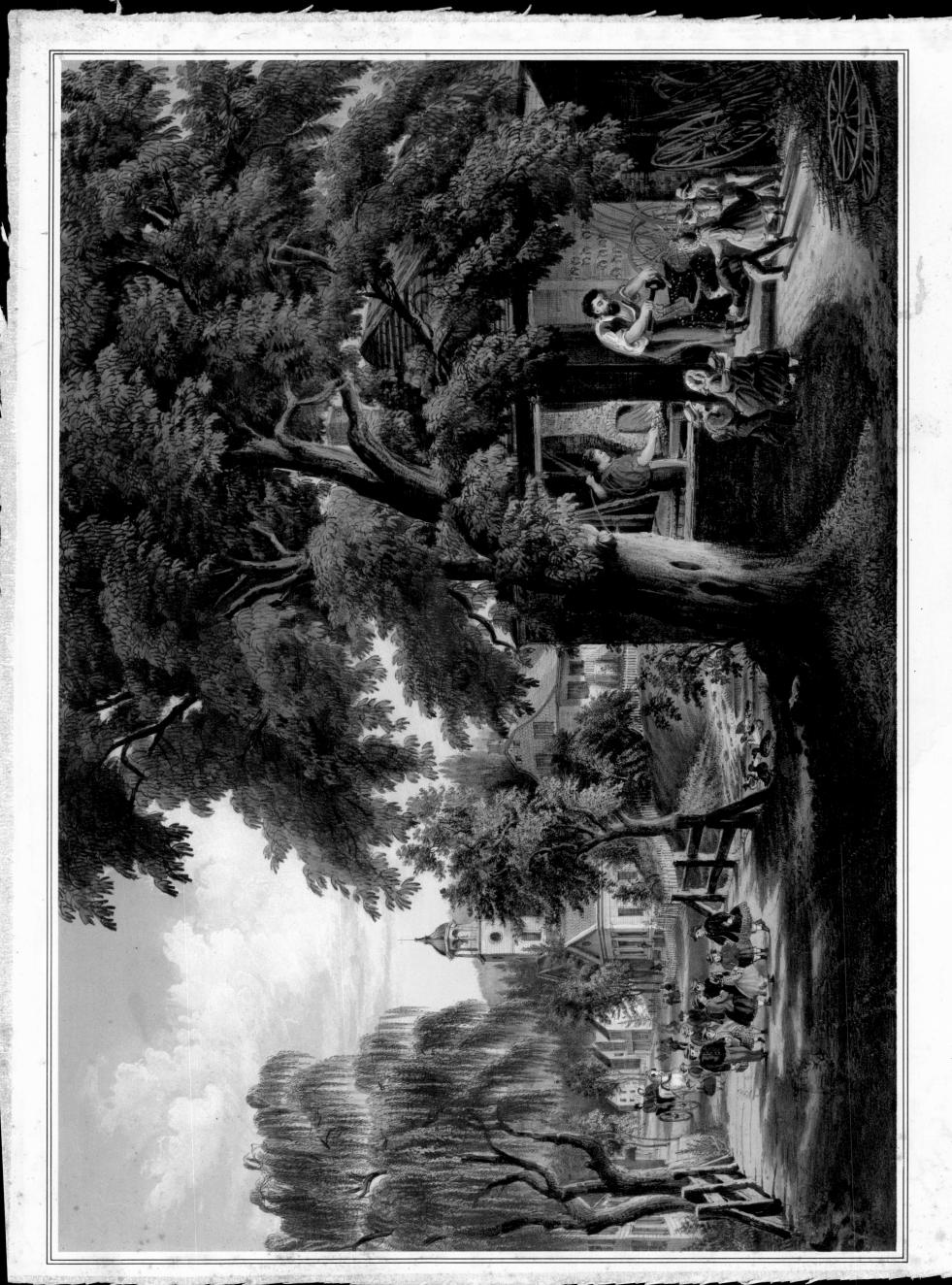

THE VILLAGE BLACKSMITH

THE CREAM OF LOVE

BECAUSE THE MUSEUM OF THE CITY OF NEW YORK houses the Harry T. Peters Collection of Currier & Ives lithographs, the largest and finest in existence, the museum receives a constant stream of letters asking for information about particular prints. In most cases it is the so-called sentimental subjects about which questions are raised. It is not possible to estimate the number of prints that were done from each stone, but the demand for the "sentimentals" must have been considerable. The firm issued about six hundred subjects in this category. One group consists of prints labeled with girls' first names. Apparently a girl would purchase or be given her "name" print. Another group delineated children and pets with such titles as *The Little Drummer Boy. Rub a Dub Dub* or *My Little White Kittens*.

Published in 1879, *The Cream of Love* perhaps epitomizes the fondness of our Victorian ancestors for the coy and the sweet, a sentimental taste that Currier & Ives capitalized on and even promoted.

The Cream of Love

HUG ME CLOSER GEORGE!

THERE WERE MORE THAN 500 different "comic prints" issued by the firm of Currier & Ives. More than half of these were the so-called Darktown comics whose humor lay in gross burlesque. Thomas Worth, the principal artist for them, claimed that 73,000 of one particular Darktown comic were sold. Even allowing for exaggeration, there is no question as to their popularity.

Of the firm's comics in general Harry T. Peters wrote that the "vitality, exuberant fancy, and obviousness are apparent, and show how quickly and definitely the popular sense of humor perhaps one of the most sensitive guides to the quality of a civilization—has changed."

Although the humor shown is usually perfectly clear without any caption, the latter explains further and emphasizes the basic theme. The 1866 print illustrated here is typical of the better level of the firm's output of humor. It is probable that this scene graced the walls of many saloons.

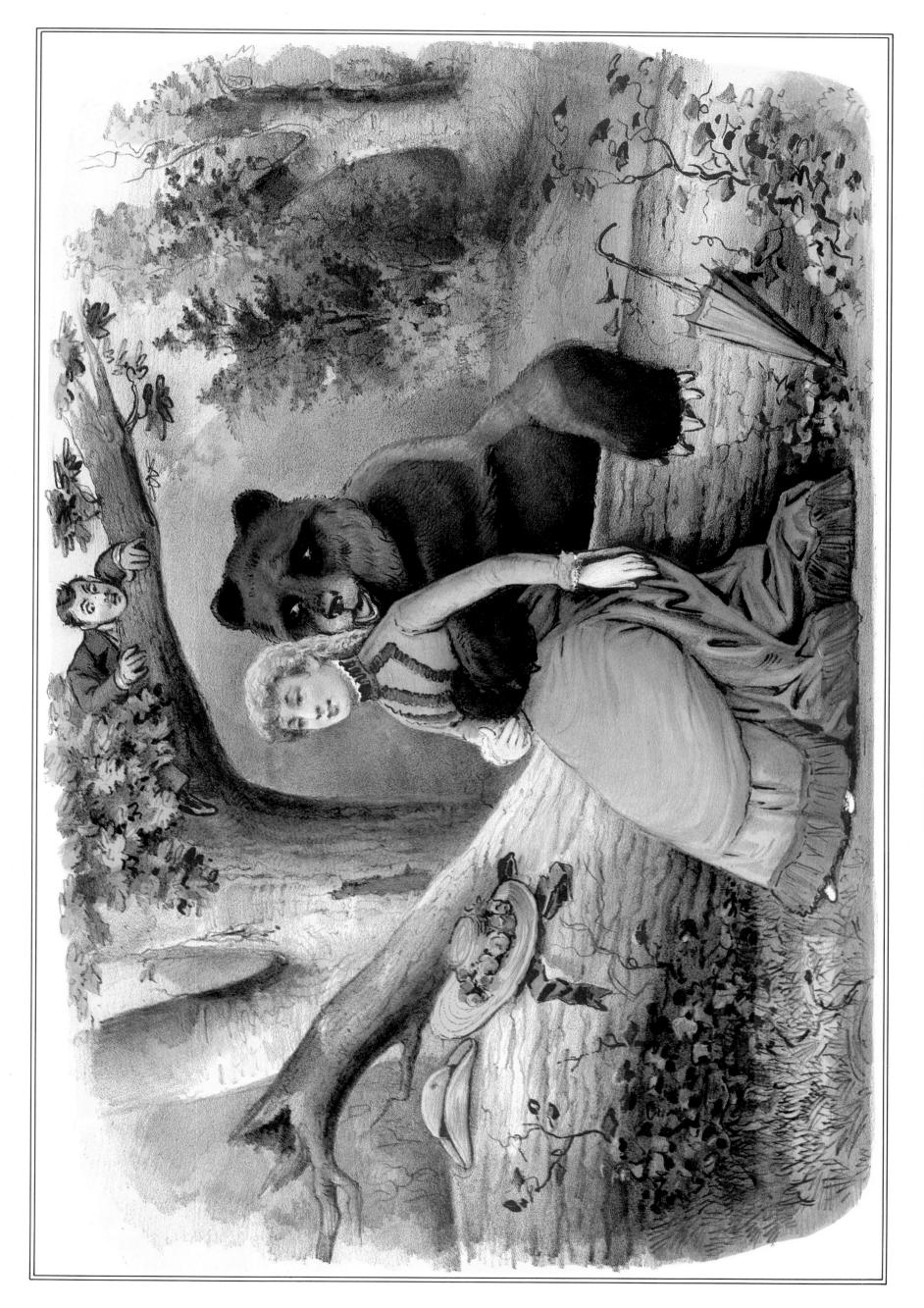

HUG ME CLOSER GEORGE!

KISS ME QUICK

ALTHOUGH CURRIER & IVES published more than 500 comic prints and about 575 that were broadly in the category of "sentimental," none could be labeled as naughty. The firm apparently did not want to alienate any Victorian sensibilities. This print, with its subtitle, "Children: this is the third time within an hour that I have placed your hats properly upon your heads.—There!!" in case the viewer missed the point—is about as racy as the firm ever allowed itself to be. A close second might be *A Beautiful Pair* in which a young shoe clerk is staring intently at the ankles of an attractive lady who has raised her skirt slightly to check some prospective new boots.

Although this print is not dated, the fact that the firm is shown as Currier & Ives (James Ives became a partner in 1857), and the costumes are prior to 1860 in style would indicate a date for the print in the late 1850s.

kiss me quick

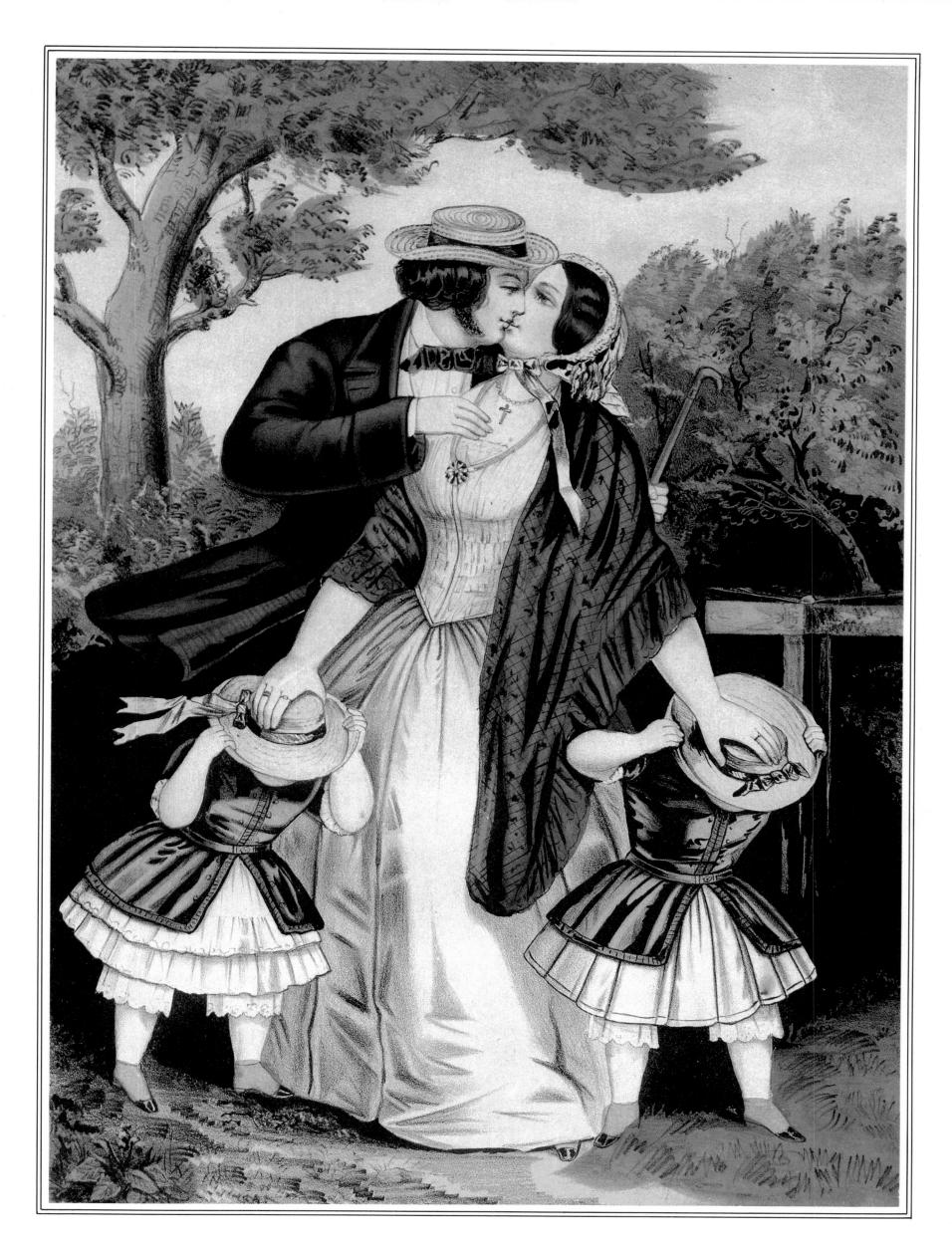

THE FOUR SEASONS OF LIFE: MIDDLE AGE

"The Season of Strength"

CURRIER & IVES DID FOUR "season of life" prints: Childhood— "The Season of Joy," Youth—"The Season of Love," Old Age— "The Season of Rest," and the one shown here. On each there are two stanzas of suitable verse by an unidentified poet. On this one the lines are: "But as the hues of summer fade away, / And varying tints, the days of autumn bring; / So life's Autumnal season, brings its gray, / And cares like ivy, to our pleasures cling. / Sweet care when home, and loving hearts, are ours, / And loving lips, breathe forth their welcome song; / For them we labor through the passing hours, / And bear our burdens, thankful we are strong."

There is one element relating to this 1868 series that is quite unusual: the artist for this one and for the one on Old Age set the scenes in interiors of homes of typical upper-middleclass, rural, Victorian families. In this scene of a father happily returning to his wife and four doting children, we see the small rug on the carpet, the shawl on the ubiquitous hat rack, and even a print on the wall that has all the earmarks of a Currier & Ives lithographed hunting scene. It is interesting that the vista seen through the open door is very typical—probably a view on the Hudson River, a favorite topic for the firm. Currier's business partner, James Ives, did the original painting, and Charles Parsons put it on stone.

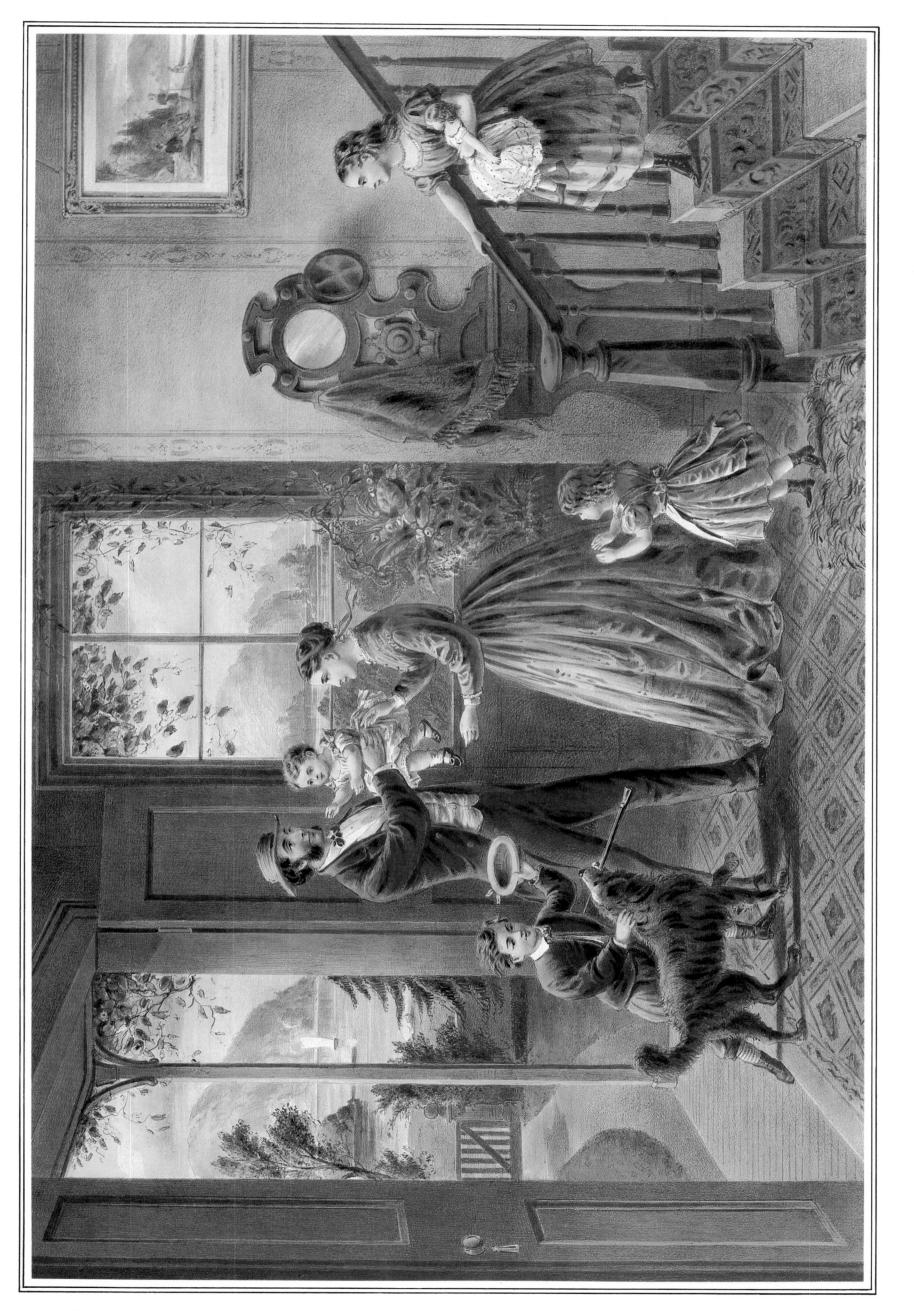

THE FOUR SEASONS OF LIFE: MIDDLE AGE

THE BLOOMER COSTUME

Few REALIZE when referring to bloomers that the term came into being through the actions of the wife of Dexter C. Bloomer, editor of the Seneca County Courier. Amelia Jenks Bloomer, an early advocate of temperance and woman's rights, started her own newspaper, the Lily, in 1849, one of the first to be published by a woman. Allied to her other crusades was the wish to emancipate women from the difficulties in wearing the long, dust-sweeping skirts of the mid-nineteenth century. Although Elizabeth Smith Miller really devised the basic costume shown in this 1851 print, it was the attention generated by Mrs. Bloomer's wearing of it and writing about it in the Lily that affixed her name to this design in the public's mind.

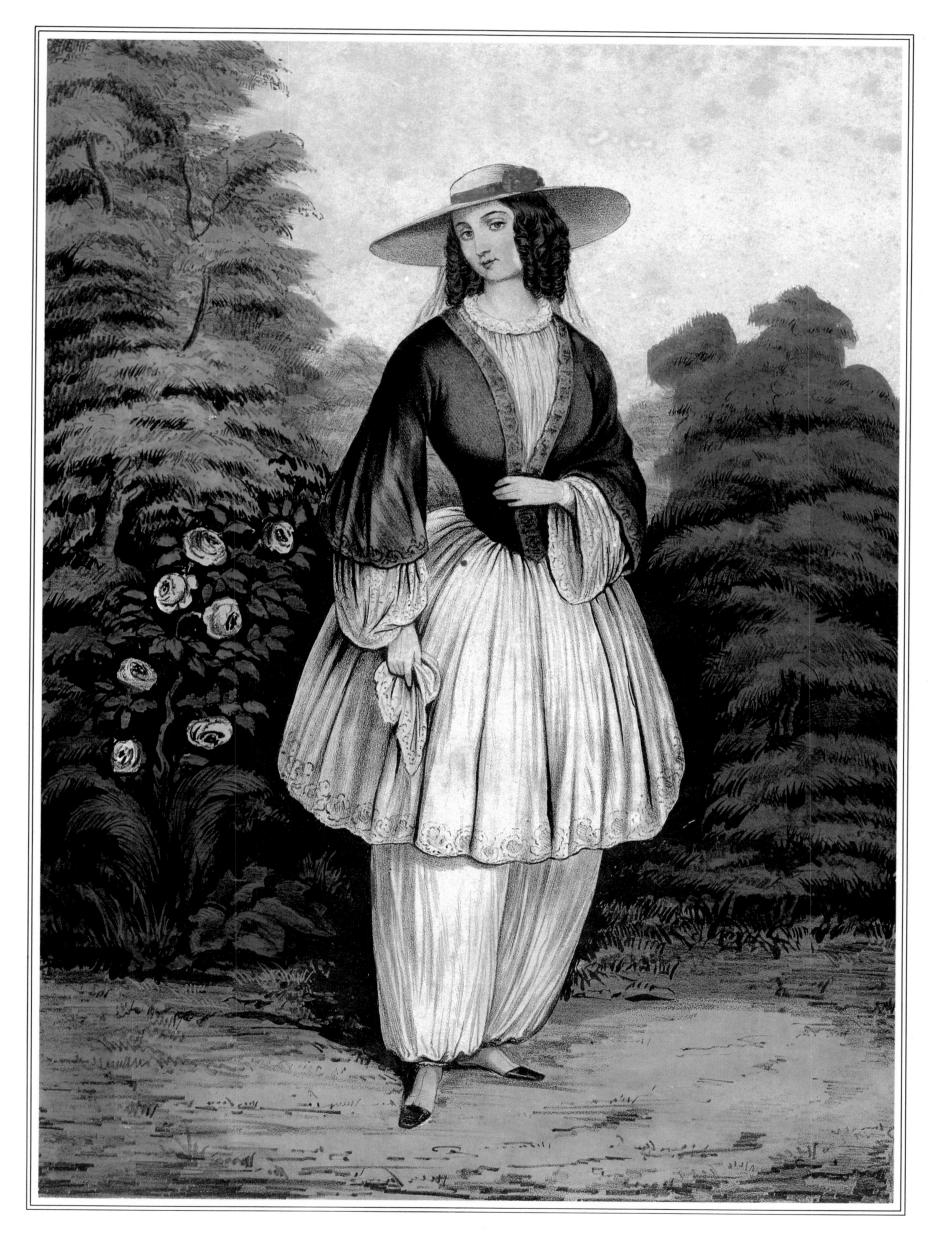

THE BLOOMER COSTUME

GLENGARIFF INN. IRELAND

BETWEEN 1846 AND 1851 nearly a million people emigrated from Ireland primarily due to the dire famine caused by the "potato rot." America received the greatest proportion of these immigrants. In the 1850 census, 962,000 were listed as having been born in Ireland. In 1851 alone, 22,000 Irish came to these shores.

With the business acumen of the firm of Currier & Ives, it is not surprising that they would cater to the nostalgia of these new immigrants by issuing as many as twenty-six lithographs of scenes from Ireland. The accuracy of the delineation might be somewhat suspect, but the titles carried the message—in almost every one the word "Ireland" was emphasized.

Glengariff, the subject of this print, was a celebrated resort for tourists in summer and invalids in winter. Inns and hotels dominated the small village lying at the northern head of Bantry Bay in County Cork. Rich vegetation grew in the rocky glen (the name means "rough valley") with a mild climate which has given Glengariff its reputation as a health resort for those suffering from pulmonary problems.

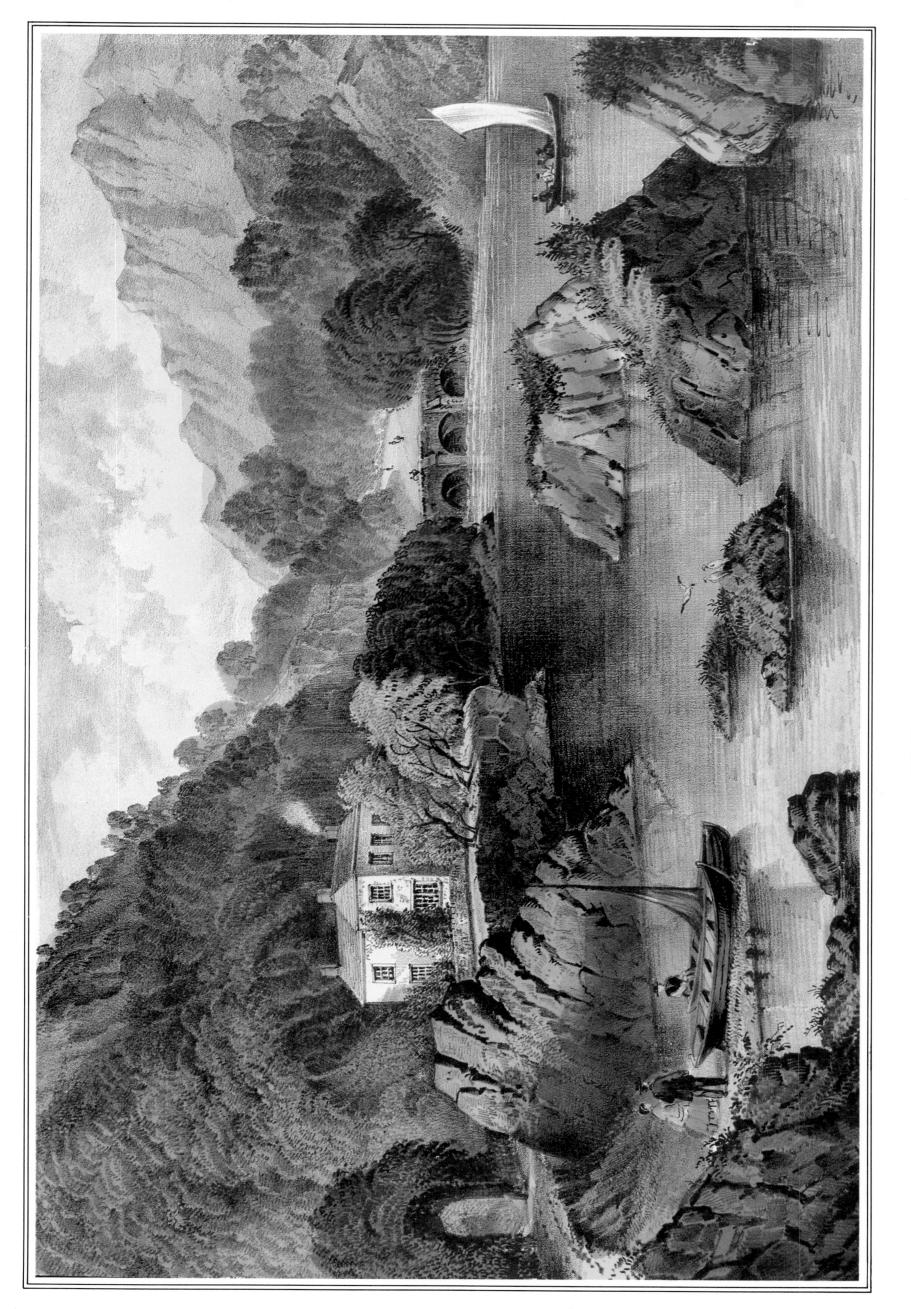

GLENGARIFF INN

ON THE FRONT COVER

THE ROAD,-WINTER

ONE OF THE MOST ATTRACTIVE of the winter scenes, this print, portraying Nathaniel Currier and his second wife (the former Lura Ormsbee of Vermont) after their marriage in 1853, was produced and presented to Currier by his employees. He thought so highly of this Christmas gift that he immediately ordered it into commercial production. It proved to be a best seller. When Christmas cards were introduced in America twenty years later, this lithograph was an ideal subject; it is still widely used in current Christmas card production. The United States Postal Service selected this print as the source for its 1974 Christmas stamp.

Otto Knirsch was the artist and lithographer. It is amusing to note that he signed his name directly on the lithographic stone; it thus appears in reverse in the lower left of the print.

ON THE BACK COVER

NOAH'S ARK

THERE IS NO EVIDENCE that either Nathaniel Currier or James Ives was of a particularly religious nature, but, always on the lookout for a popular market, the firm produced at least 185 different prints on religious subjects with six versions of Noah's Ark alone. Many of the prints were inspired by famous Renaissance paintings; no acknowledgment to the original artists was made, however. With an eye to the foreign-born, many of the prints were titled in French and in Spanish.

In this fanciful rendition of Noah's Ark, it is interesting to note Napoleon Sarony's signature in the lower left. He was associated with Nathaniel Currier and Currier & Ives for many years as artist and lithographer. Despite the professional competition of his own rival business, this association seems to have flourished.